A QUENTIN TARANTINO DICTIONARY

A QUENTIN TARANTINO DICTIONARY

An A–Z of the iconic director and his work, from AK-47 to Zed

HELEN O'HARA

ILLUSTRATIONS BY
LAURÈNE BOGLIO

WELBECK

CONTENTS

6 *Introduction*

10 *A–Z*

222 *About the author*

222 *Acknowledgements*

INTRODUCTION

You know a director has *really* made it when they get their own adjective: Spielbergian; Hitchcockian; Tarantinoesque. What's remarkable about Quentin Tarantino is how quickly he gained that status. It took him less than five years to go from video store clerk to superstar director, with 1994's *Pulp Fiction* shattering box-office records and winning him an Academy Award for Screenwriting. More than any director since Spielberg – maybe more than any director ever – Tarantino became the personality and selling point of his films. That has sometimes made him a target for criticism – particularly in his fondness for bad language and ultra-violence – but it has also made him wildly popular with generations of film lovers.

This book is an attempt to categorize some of the work that has made Tarantino such a huge figure in modern filmmaking, and to examine – briefly; we do not have enough time to be as verbose as the director himself – the highs and lows of his career. For the most part we won't get too far into the weeds with Tarantino's interests and preoccupations (see: Feet) because he has such an agile mind and such wide-ranging fandoms that we'd be left with no room for his own projects; the films he has written, directed or starred in, or the ones where he just dressed up like Elvis (see: *The Golden Girls*).

Hopefully this is a book where you can pick an entry almost at random and learn something new about the director (see: Big Jerry) and come away with a new appreciation for his work. You can learn about his connection to Britney Spears (see: A Band Apart) or his favourite ice-cream flavour (see: Condorman Crunch). What's striking as you read more and more about Tarantino is the immense

affection that almost all his co-workers seem to have for him. Actor after actor has described the warm atmosphere and sense of ease that pervades Tarantino's shoots, and noted how delighted he seems to be each time he gets behind the camera. Perhaps the secret of his success is ultimately as simple as loving his work: he's the film geek who gets to live out his dreams. Orson Welles called a movie in production "the biggest electric train set any boy ever had" (see: *Saturday Night Live*) and Tarantino seems to agree. For all the violence, blood and gore, there's something pure and idealistic in Tarantino's films, a hopefulness that sometimes belies his characters' cynicism.

If he does retire from filmmaking after his tenth effort, as he claims he will (see: Ten Movies), cinema will be the poorer for it. Tarantino's efforts to mentor younger filmmakers and his plans to continue writing mean that his influence will linger long after we see the last new Tarantino film in cinemas, ideally on film. Maybe he'll even get back into acting (see: Cameos). There's no question that cinema is richer for having had him as a fan. The rest of us movie fans can only dream of the kind of legacy he'll leave behind.

Helen O'Hara

A BAND APART

SEE ALSO:

Bender, Lawrence

Quentin Tarantino Presents

Rolling Thunder Pictures

"Telephone"

Tarantino founded his own production company in 1991 before the release of his first film as director. The name is a homage to the 1964 Jean-Luc Godard-directed, French New Wave classic *Bande à Part* (released in the US as *Band Of Outsiders*), starring Anna Karina and Sami Frey. Tarantino partnered with his regular producer, Lawrence Bender, then they brought aboard Michael Bodnarchek in May 1995 to create a music video and advertising arm to the company. The company acted as a production entity on Tarantino's work (such as for *Four Rooms*) but its mission extended further. A Band Apart was credited on Tarantino-related films including *From Dusk Till Dawn* and Bender productions like *Good Will Hunting* and *Dirty Dancing: Havana Nights*.

Its shorter-form content also proved memorable. Music videos made under the banner include Will Smith's "Miami", NSYNC's "Bye Bye Bye" and Britney Spears' "Oops!...I Did It Again". According to Bodnarchek, "At one point in 1999 A Band Apart music videos accounted for over 70 per cent of all music video content in the world." Bender left the company in 2005 and Bodnarchek a year later, when it essentially ceased operation. However, A Band Apart's name remained attached to Tarantino films like *Inglourious Basterds* and *Django Unchained* until the latter's release in 2012.

ACADEMY AWARDS

The Academy of Motion Picture Arts And Sciences has handed out the biggest prizes in Hollywood's awards season every spring since 1929. Tarantino has been personally nominated for awards on eight occasions, for writing, directing and producing his films. The Academy has awarded him Best Original Screenplay twice, for *Pulp Fiction* and *Django Unchained*. When presented with the former award by Anthony Hopkins, Tarantino threatened a lengthy speech distilling everything he had learned during the long year launching *Pulp Fiction* to the world, but he ultimately restrained himself to a simple thanks. Second time around, Tarantino was more prepared, and gave credit to his cast for bringing his characters to life and paying tribute to his fellow nominees. There was controversy among Tarantino fans when *Pulp Fiction* lost Best Picture in the 1994 awards to *Forrest Gump* in one of the least-popular decisions of all time, but Tarantino himself can take comfort from his two prizes, his nominations and the wins his actors have racked up: two for Christoph Waltz and one for Brad Pitt.

SEE ALSO:

Avary, Roger

Django Unchained

Forrest Gump

Pitt, Brad

Pulp Fiction

Waltz, Christoph

AK-47

The Avtomat Kalashnikova, aka the Kalashnikov after its inventor Mikhail Kalashnikov, is an assault rifle

A

introduced to the Soviet army just after World War II. It's relatively cheap to produce, famously reliable even in extreme conditions and is, in the words of Jackie Brown's gun runner Ordell Robbie (Samuel L. Jackson), "The very best there is. When you absolutely, positively got to kill every motherfucker in the room, accept no substitutes …"

ALIAS (2001)

The 2001 TV spy series, created by JJ Abrams and starring Jennifer Garner, had a fan in Tarantino from the beginning. That's why Abrams asked him to guest star in a two-part centrepiece to season one, "The Box". In it, Tarantino plays McKenas Cole, a former agent abandoned by the show's super-secret spy agency SD-6 during a mission. He returns to occupy the agency's headquarters and break into their vault. Garner's Sydney Bristow has to crawl about the air ducts dismantling explosives to thwart him, while Cole busies himself torturing SD-6 boss and cold-blooded villain Arvin Sloane (Ron Rifkin). The parallels to John McTiernan's *Die Hard* are very much deliberate – Cole's gang turns up in a van marked "McTiernan air-conditioning" – but Cole feels tailormade for Tarantino, mostly because he was. He swaggers about in a cool suit, has a deadly and beautiful girlfriend/accomplice, and spouts witty dialogue about junk food and pop

SEE ALSO:

All-American Girl

CSI

Kill Bill: Vol. 1

culture. Cole even gets to land a few punches on the unstoppable Sydney before, inevitably, being taken into custody. But he escapes! Tarantino returned in the thirteenth episode of season three, "After Six". By this point Cole has risen in the world, wearing an impeccable tuxedo and acting as second-in-command to big bad "The Man" (actually Sydney's KGB agent mother!). He conspires with recurring bad guy Julian Sark (David Anders) and coincidentally shares the episode (though not a scene) with his future *Kill Bill* star, Vivica A. Fox. Cole's never seen again, so he's presumably still out there somewhere in the *Alias* universe.

ALL-AMERICAN GIRL (1995)

Comedian Margaret Cho starred in this self-penned sitcom for one season in 1994. At the time she was dating Tarantino, who guest-starred in an episode called "Pulp Sitcom" (a title written in the movie's style, with a "Misirlou"-esque musical sting) in the spring of 1995. He plays Desmond Winocki, a video store salesman and movie nerd (talk about casting to type), who Margaret comes to like. They go out to a distinctly *Pulp Fiction*-esque '70s-themed restaurant (where they disco dance badly) and there are lots of unsubtle references to the hit movie, including Desmond claiming that *Speed* is "a little too violent" for his tastes; his briefcase opening to

SEE ALSO:

Alias

CSI

Keitel, Harvey

Pulp Fiction

reveal a golden glow caused by a reading light; and him stabbing a turkey with a meat thermometer in true Mia Wallace/adrenaline style. It's very broad and silly – like the accents he attempts throughout – but more charming than many of his cameos as creeps or weirdos. Alas for his romantic prospects, it turns out his videos are bootlegs, and while the Kims help him escape his boss, he still leaves town ahead of the cops. An out-of-character scene over the end credits sees Tarantino arguing with Cho over further acting work – "No more episodic television!" – which feels like a gag at his own expense, given his enthusiasm for cameos at the time.

ANDERS, ALLISON

One of Tarantino's contemporaries at the Sundance Filmmakers Lab was Allison Anders, who would go on to direct *Gas Food Lodging* in 1992, the same year he made *Reservoir Dogs*. Anders started her career as a production assistant on Wim Wenders' cult hit *Paris, Texas* and met Tarantino as they both worked on their directorial debuts. They dated briefly, but quickly realized that they were far more interested in talking about film than one another. The pair then collaborated, along with Robert Rodriguez and Alexandre Rockwell, on *Four Rooms*, with Anders directing the segment titled "The Missing Ingredient". After that slightly soured relations

SEE ALSO:

Avary, Roger

Four Rooms

Sundance Film Festival

between the four directors, Anders went on to direct films like *Mi Vida Loca* and *Grace of My Heart*, as well as having a distinguished career in TV on shows like *Sex And The City*, *Orange Is the New Black* and *Riverdale*. She's the recipient of a MacArthur Genius Grant and a Peabody Award, as well as numerous Independent Spirit nominations.

AVARY, ROGER

Roger Avary worked with Tarantino at the Video Archives VHS rental store when both were in their early twenties. The pair bonded over their nearly insatiable appetite for movies, and both began careers as filmmakers. Avary was one of the cinematographers on Tarantino's abandoned debut *My Best Friend's Birthday*, and worked with Tarantino on Dolph Lundgren's *Maximum Potential*. One of their early projects was an anthology film, with each of them planning to write and direct one of three parts, but they could never find a third partner, so they abandoned the idea. Avary's story for that film eventually became the basis of the "gold watch" segment of *Pulp Fiction*; he was credited with Tarantino as a screenwriter on the movie and shared the Academy Award for Best Original Screenplay. Avary made his own directorial debut with *Killing Zoe* in 1993, a nihilistic bank heist thriller starring Eric Stoltz, Jean-Hugues Anglade

and Julie Delpy. The film shared a producer with *Reservoir Dogs* in Lawrence Bender, and was shot in a location Bender found while scouting for that film. It received hostile reviews but a warm reception at Cannes, taking home the Prix Très Spécial that was awarded for twenty years or so to "singular, strong and offbeat" works including *Re-Animator*, *Funny Games* and *Happiness*. Later, Avary worked on a 2002 adaptation of Bret Easton Ellis' *The Rules Of Attraction*, a 2006 adaptation of the game *Silent Hill* and Robert Zemeckis' 2007 animated *Beowulf*. In 2022, he and Tarantino teamed up once more for the *Video Archives* podcast, with Avary's daughter Gala as their announcer and producer.

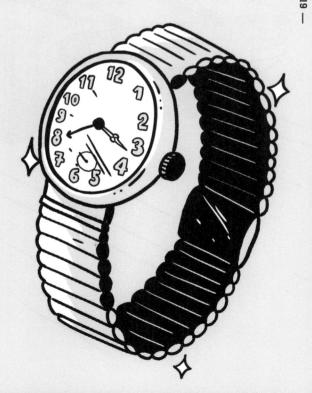

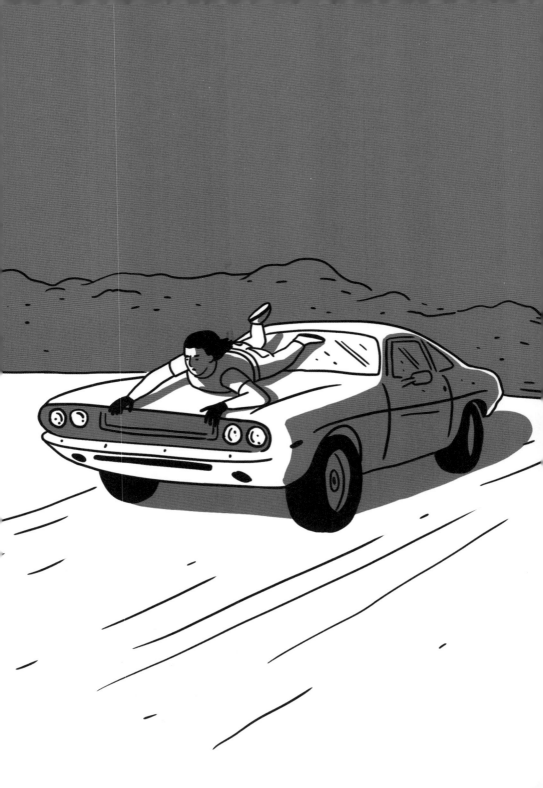

BELL, ZOË

New Zealand actress Zoë Bell began her stunt career after her doctor father treated an injured stuntman and brought home his contact details. The sporty Bell did her first stunt aged just fourteen, jumping out of a car on the Kiwi soap *Shortland Street*. A few years of training later, she joined the cast of *Xena: Warrior Princess* in season four, becoming the regular stunt double for Lucy Lawless' Xena. Bell began working with Tarantino on *Kill Bill*, initially as a "crash and smash" double for Uma Thurman. Quickly, her talent and resemblance to Thurman made her an obvious choice for fight scenes, so she learned the film's wushu style and was nominated for four Taurus World Stunt Awards across the two volumes of the film. Tarantino then cast her in a leading role in *Death Proof*. There, she plays a character called "Zoë Bell" who does incredible stunts, like clinging to the hood of a 1970 Dodge Challenger at 90mph (Bell had to be reminded to show her face to the camera after years of hiding it). Bell worked with the director on *Inglourious Basterds*, where she doubled for both Shoshanna and Bridget von Hammersmark; *Django Unchained*, where she cameoed as a tracker; *The Hateful Eight*, where she plays "Six-Horse Judy"; and *Once Upon a Time ... in Hollywood*, where she has a memorable cameo as Janet Lloyd – the disapproving wife

SEE ALSO:
Death Proof
Django Unchained
The Hateful Eight
Inglourious Basterds
Kill Bill: Vol. 1
Kill Bill: Vol. 2
Once Upon a Time ... in Hollywood
Xena: Warrior Princess

to Kurt Russell's Randy Miller – as well as being credited as stunt coordinator. Outside her work with Tarantino, Bell was Cate Blanchett's double as the goddess Hel in *Thor: Ragnarok*, and worked on everything from *Whip It* to *Malignant*.

BENDER, LAWRENCE

SEE ALSO:

| A Band Apart |
| *Four Rooms* |
| *Inglourious Basterds* |
| *Jackie Brown* |
| *Kill Bill: Vol 1* |
| *Kill Bill: Vol 2* |
| *Pulp Fiction* |
| *Reservoir Dogs* |

Lawrence Bender was a producer on every Tarantino film from *Reservoir Dogs* until *Inglourious Basterds*. Before *Dogs* he had only two other projects under his belt: supermarket slasher *Intruder* and Charlie Sheen drama *Tale of Two Sisters*. Bender had trained as an engineer and worked as a dancer before injuries forced him to consider another career. Perhaps those early experiences gave him the analytical, problem-solving skills and flexibility necessary to become a producer, because he proved a huge success for Tarantino. He managed the very limited budget on *Reservoir Dogs* and the huge stars of *Pulp Fiction* alike, and in 1997 succeeded in producing *Jackie Brown* and *Good Will Hunting* simultaneously (at least for three weeks of the overlapping shoots). He's been nominated for Best Picture at the Oscars three times, for *Pulp Fiction*, *Good Will Hunting* and *Inglourious Basterds*. In between Tarantino projects Bender worked on films like *The Mexican*, *Knockaround Guys* and Al Gore's Oscar-winning documentary *An Inconvenient*

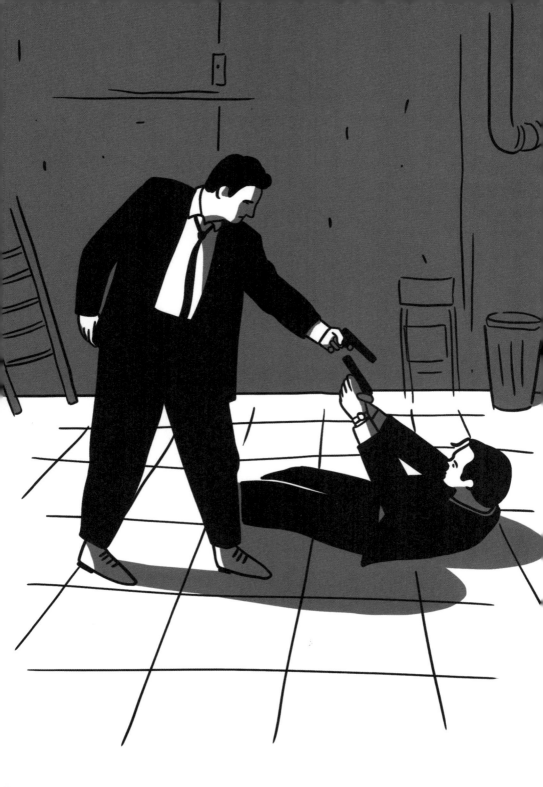

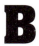

Truth. He stopped working at their A Band Apart production company in 2005 after what he once called a "falling out" with Tarantino, the origins of which have never been revealed. They reteamed for *Inglourious Basterds* in 2009, but so far that remains their final collaboration. Bender also had cameo roles in numerous Tarantino films, appearing briefly as a cop in *Reservoir Dogs*, as a hotel clerk in *Kill Bill: Vol. 2*, and as "long-hair yuppy scum" in *Pulp Fiction*, *Four Rooms* and *Fresh*. Hopefully that wasn't typecasting.

BIG JERRY

Cast and crew members who fall asleep on Quentin Tarantino film sets are apt to wake up to find their face being nuzzled by a gigantic purple dildo called "Big Jerry". Various actors miming the Big Jerry experience suggest that it is about the size of a fire hose. A picture of the offender, and Big Jerry, will then be posted on a wall of shame on the set. Tarantino has also been known to have the photos printed on T-shirts. This is apparently successful in discouraging dozing.

BIG KAHUNA BURGER: SEE RED APPLE CIGARETTES

BOND, JAMES

For a long time, Tarantino wanted to make a Bond film. After *Pulp Fiction* he tried to acquire the rights to *Casino Royale*, which had been sold separately from the other Bond stories by author Ian Fleming. He planned to make a 1960s period adaptation set just after *On Her Majesty's Secret Service*, with a Bond still mourning his assassinated wife, Tracy, when he meets *Casino Royale*'s Vesper Lynd. Unfortunately, Bond producers EON had spotted the possibility of someone nabbing the book and made a deal with the Fleming estate to prevent any such challenge to their ownership. Later, just after *Kill Bill: Vol. 2* in 2004, Tarantino invited Pierce Brosnan to meet at the Four Seasons in Hollywood and pitched him the idea. He liked Brosnan's take on the character and hoped to cast him as Bond once again, continuity be damned. Again, EON said no. Tarantino was disappointed, saying in 2007, "I don't think I ever came close to it; I don't think they ever considered me... I could never really imagine doing it with the Broccolis (Bond producers) for the simple fact that they are never going to give me... final-cut control." *Casino Royale* was eventually adapted by EON in 2006 with Daniel Craig playing Bond in the opening salvo to a whole new take on the character, but still a modern-day hero. The prospect of a 1960s-set, book-faithful Tarantino Bond remains

SEE ALSO:

Unmade films

SEE ALSO:

The Golden Girls

Pulp Fiction

Quiff

one of the great might-have-beens of Tarantino's career, and of the spy's.

BRIEFCASE

Tarantino likes leaving mysteries in his films. He wants the audience to make up their own solutions, giving each person an individual viewing experience. *Once Upon a Time … in Hollywood*, for example, is a very different movie if you think that Cliff Booth killed his wife by accident than if you think he did it on purpose. But the most famous unsolved mystery in all his films, and one that Tarantino says he will never answer, concerns the contents of the briefcase in *Pulp Fiction*. Each time that key prop is opened, a golden light shines out; everyone recognizes that its contents have value, and Tim Roth's Pumpkin even seems to recognize whatever's in there ("Is that what I think it is?"). So is it gold bars? It looks too light. Some suggest that it was Elvis' gold suit, worn on the cover of the compilation album 50,000,000 *Elvis Fans Can't Be Wrong* (Tarantino enjoyed that theory but rejected it). Others have suggested the Holy Grail, God itself or simply heroin. The most popular theory is that it contains Marsellus Wallace's soul, hence the plaster on the back of his neck where it was extracted. Sure, some boringly plausible interviews have said that this was simply to cover a scar on actor Ving

Rhames' neck that he didn't want on camera, but that is no bar to a wild theory. The point is that the briefcase is a hugely successful MacGuffin, a movie term popularized by Hitchcock that refers to the thing that everyone in a film wants, or that drives the plot forward.

BROADWAY: SEE *WAIT UNTIL DARK*

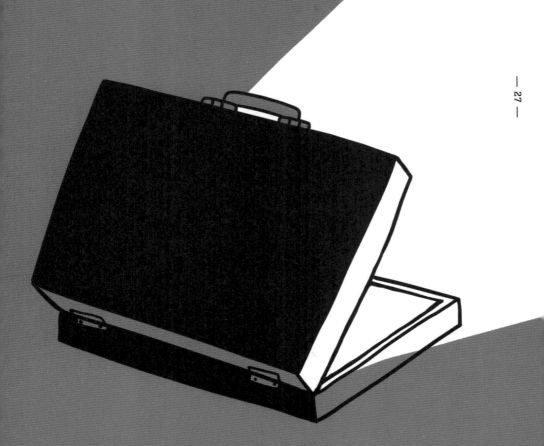

C

CABO AIR: SEE RED APPLE CIGARETTES

CAMEOS

SEE ALSO:

Desperado

Django Unchained

From Dusk Till Dawn

Girl 6

Inglourious Basterds

Planet Terror

Pulp Fiction

Reservoir Dogs

Alfred Hitchcock may have been more prolific, but Quentin Tarantino relishes taking cameos and even major roles. What's unexpected in his case is how much he enjoys playing despicable people. His official credit on *Planet Terror* is "Rapist #1". He not only gets a spectacularly gory exploding-head death, but also has his penis decay into slime and literally drop off. He also plays a rapist in *From Dusk Till Dawn* and an enthusiastic sexual harasser in both *Girl 6* and one of his *Saturday Night Live* sketches. He's a slave trader in *Django Unchained*, a Nazi being scalped in *Inglourious Basterds* and the butt of a series of physical comedy gags in *Little Nicky*. In *Reservoir Dogs*, *Pulp Fiction* and *Desperado* he's the least-cool person in the entire film. He displays no ego at all in his acting choices: all the more extraordinary when you consider that he wrote many of these roles and actively chose to take the most gross character. Perhaps it's an act of generosity to his cast. He doesn't ask them to do anything he wouldn't do himself, and then some.

CANNES FILM FESTIVAL

As a young man Tarantino dreamed of just attending Cannes, never mind premiering a film there. He had to adjust his aspirations upwards almost at once. He has been a Cannes darling since he first attended in 1992 with *Reservoir Dogs*, and he won the Palme d'Or in 1994 when he screened *Pulp Fiction* in competition. That win surprised Tarantino; he said in his speech, "I never expect to win anything when a jury has to decide because I don't make the kinds of movies that bring people together. I make the kinds of movies that split people apart." Jury president Clint Eastwood said that his panel found the film "original" and that that was the key. Ten years later, in 2004, Tarantino headed the Festival's jury, awarding Michael Moore's *Fahrenheit 9/11* the Palme d'Or and Park Chan-wook's *Oldboy* the Grand Prix. Tarantino visited again with *Inglourious Basterds* and *Once Upon a Time ... in Hollywood*, always to huge excitement from the crowds on the Croisette.

SEE ALSO:
Inglourious Basterds
Once Upon a Time ... in Hollywood
Pulp Fiction
Reservoir Dogs

CAREER RESURRECTIONS

A side-effect of Tarantino's near-encyclopaedic cinema viewing, especially post-1960s, is that he knows the career trajectory of many fallen stars and coulda-beens. He has seen the obscure debuts

SEE ALSO:
Cinema Speculation
Madsen, Michael
Parks, Michael
Travolta, John

C

of many future big names, and the poor choices that led to some of those names becoming has-beens. However, he also knows where Hollywood has squandered huge potential, and that has given him an almost unique ability to kick someone's career back into gear. Beneficiaries of this treatment include Michael Madsen in *Reservoir Dogs*, Robert Forster in *Jackie Brown* and the recurrent appearances of Michael Parks. Perhaps the most famous example is still John Travolta in *Pulp Fiction*, who essentially catapulted himself back onto the A-List thanks to the critical acclaim and Oscar nomination he received for that performance. Tarantino also loves to pay tribute to his heroes by casting them in smaller roles in his films, frequently leading his fans to seek out their earlier work to see what all the fuss is about. Good examples are martial arts legend Sonny Chiba in the small but delightful role of Hattori Hanzo in *Kill Bill: Vol. 1*, showcasing his comic and acting skills, or Franco Nero, the original Django of spaghetti Western fame, in *Django Unchained*.

***CASINO ROYALE*: SEE BOND, JAMES**

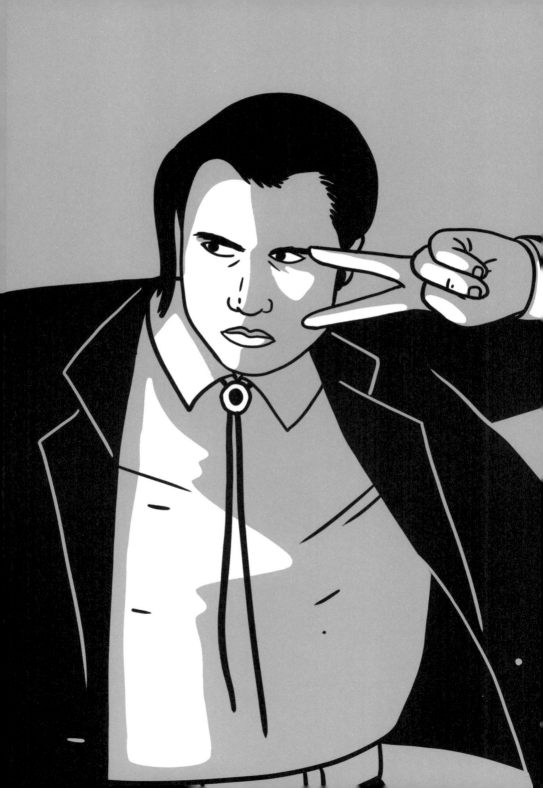

C

SEE ALSO:

Ten Movies

Zastoupil, Curtis

CINEMA SPECULATION

Tarantino's second book is somewhere between a collection of criticism and a personal memoir. The writer-director recalls a cinema-going youth, choosing to focus in on a series of films from the 1960s and 1970s that stuck particularly vividly in his memory. By his own account, his mother and stepfather, Curtis Zastoupil, took him to the cinema with them from the age of seven, when he went to the Tiffany Theater on Sunset Boulevard to see a double-bill of John G. Avildsen's *Joe* and Carl Reiner's *Where's Poppa?* These were two thoroughly adult films that the young 'Quint', as he was nicknamed, was expected to watch quietly, lest he be left with a babysitter in future. So began his education in the adult-oriented films of the '70s. In the years following he'd see classics like *M*A*S*H* and the *Dollars* trilogy. *Carnal Knowledge* baffled and bored him; the freeze-frame ending of *Butch Cassidy and the Sundance Kid* frustrated him. But his love of cinema itself grew stronger. Tarantino spends much of the book discussing how his highlighted films compared to their contemporaries, how they might have turned out better or worse, and sometimes what lessons he took into his own filmmaking. As well as covering well-known films like *Bullitt*, *Dirty Harry* and *Taxi Driver*, he takes in lesser-known works like *The Funhouse*, *The Outfit* and

Paradise Alley. *The Guardian* called it "rollicking" but also "ramshackle" – but then Tarantino was not attempting a systematic dissection of '70s cinema. In fact, this reads like the opening chapter in a larger, longer endeavour, one that might lead him to write more film criticism in future.

CONDORMAN CRUNCH

A short-lived Baskin Robbins flavour tie-in to the film *Condorman*, this was described by the company as "chocolate ice cream with crunchy praline pecan bits and a milk chocolate ribbon". Tarantino named it as his favourite flavour in a 2015 interview with *The New York Times*. Of course his favourite flavour is a long-forgotten ice cream tied to an obscure box-office flop. *Condorman* itself was a superhero disaster of 1981, directed by Charles Jarrott and starring Michael Crawford (*Some Mothers Do 'Ave 'Em*, *The Phantom of the Opera*) as the winged hero.

CRIMSON TIDE (1995)

After making his name with *Reservoir Dogs* and *True Romance* but before the monumental success of *Pulp Fiction*, Tarantino gained a reputation as a script doctor. He's known to have worked on Tony Scott's 1995 submarine thriller, starring Denzel Washington and Gene Hackman. During a possible right-wing

SEE ALSO:

True Romance

Star Trek

Unmade films

Video Archives (store)

coup in Russia, the US submarine *Alabama* puts to sea with orders to launch a pre-emptive nuclear strike if the rebel leader threatens the USA. Captain Frank Ramsey (Hackman) prepares such a launch after receiving an Emergency Action Message; executive officer Lieutenant Commander Ron Hunter (Washington) urges caution because of a second, incomplete message that may have been intended to countermand the first. Under attack from a rogue Russian sub, the two men clash over an action that could start a global nuclear apocalypse, in a gripping struggle for power. The screenplay is credited to Michael Schiffer, who also wrote *The Peacemaker* and video game *Call of Duty*, but at some point Scott wanted to inject some pop culture fun and suggested his *True Romance* screenwriter, Tarantino. The result was a spiel by Washington's otherwise serious-minded executive officer on the importance of comic book character the Silver Surfer and a scene riffing on *Star Trek* when he's trying to get another sailor's cooperation. Tarantino added the character of Russell Vossler (named after a friend from his old Video Archives days) who must repair the radio to confirm the vital order.

CSI (2005)

Tarantino fell for *CSI* after bingeing it while he was making *Kill Bill*. The following year, he directed the

SEE ALSO:

Alias

Kill Bill: Vol.2

C

two-part season five finale, based on his own story. In "Grave Danger", CSI tech Nick Stokes (George Eads) is drawn to a deserted street to investigate apparent human remains. He is abducted and sealed in a glass coffin, buried somewhere outside town. His colleagues are investigating when a ransom note and video link arrives. Catherine Willows (Marg Helgenberger) raises money from her estranged casino-owner father, and Gil Grissom (William Petersen) goes to deliver it – only for the kidnapper (John Saxon) to blow himself up. End of part one: the search continues in part two. Tarantino helped to sprinkle some star names in the episode: no less than Hollywood legend Tony Curtis cameos as himself (making fun references to his *Some Like It Hot* co-star Jack Lemmon) opposite Frank Gorshin, TV's Riddler, who died just before the episode aired (it's dedicated to him). Tarantino restrained his swearier language for network TV, but recognizable touches shine through. Grissom has a chat with Jorja Fox's Sara about Roy Rogers' horse Trigger, a Tarantino favourite, while Nick hallucinates his own autopsy, with his uncaring colleagues taking a chainsaw to his chest in a spray of blood (this is in black and white, to avoid problems with censors). There is also, of course, someone buried alive in a nod to *Kill Bill: Vol 2*. The episode earned Tarantino an Emmy nomination (he lost out to JJ Abrams for the *Lost* pilot) and was a hit with fans.

D

DALTON, RICK: SEE THE FILMS OF RICK DALTON

DAVE DEE, DOZY, BEAKY, MICK & TICH: SEE SOUNDTRACKS; WRIGHT, EDGAR

DEATH PROOF (2007)

SEE ALSO:

Bell, Zoë

Grindhouse

Rodriguez, Robert

Russell, Kurt

Ten Movies

Tarantino's fifth film began life as half of the *Grindhouse* double bill, a collaboration with his friend Robert Rodriguez. It's a celebration of practical stunt performance in Hollywood history – even if the stuntman is a bad guy – and a new departure into female ensemble casting. It's also very much a film of two halves. The first half sees female friends on a night out in Austin, Texas, stalked and murdered by Stuntman Mike (Kurt Russell), who also merrily kills hanger-on Pam (Rose McGowan) after offering her a lift home in his "death-proof" stunt car (the catch is that it's only death-proof for the driver). After Mike successfully kills all five women and escapes because the police, embodied by Michael Parks' Earl McGraw, can't prove it was deliberate, he tries to pull the same trick fourteen months later. He stalks Abby (Rosario Dawson), Lee (Mary Elizabeth Winstead), Kim (Tracie Thoms) and Zoë Bell (Zoë Bell). But after a moment in black-and-white, the colour drops in and we notice that their car is painted like the Bride's suit in *Kill Bill* (its interior colouring is an exact replica of that film's Pussy

Wagon, too), and that Lee is wearing a cheerleader uniform that says "Vipers" on it. As was often the case in grindhouse cinema, these references to a successful film of the past few years are a clue and a cue to the audience. Mike is in for a very bad day. His attempts to run Abby, Kim and Zoë off the road while they joyride in – or in Zoë's case, car-surf on – a Dodge Challenger are foiled when he's matched by Kim's driving abilities and then shot in the arm. The trio of women (Zoë survives being thrown off the front of the car, because she's Zoë Bell) then chase him down and straight-up murder him. It's an abrupt ending, in keeping with the grindhouse ethos of cutting all extraneous (and some necessary) fat from the film. But it left viewers with unanswered questions, like the fate of Lee, who was last seen left with a redneck who seemed to have at least sexual harassment on his mind. As with *Planet Terror* and the fake trailers and adverts they made for the *Grindhouse* project, the picture is deliberately presented with scratches, imperfect edits and even a changed title ("Quentin Tarantino's Thunder Bolt" briefly appears onscreen before it is replaced with the title "Death Proof"). This was the first and so far only time that Tarantino acted as his own cinematographer on a feature, which gave him the chance to fully relish shooting an epic car chase between Mike's 1969 Dodge Charger and the

girls' 1970 Dodge Challenger. He also appears as a bartender when the first trio of girls are drinking, while songs from other Tarantino films appear on its jukebox (no surprise there: it was Tarantino's own, shipped in for the shoot). While there are some bravura moments and great car stunts, this is generally considered a lesser Tarantino effort. The director called it "the worst film I ever made" at a 2012 directors' roundtable discussion for *The Hollywood Reporter*, but he followed that with, "so if that's the worst I ever get, I'm good... It's a grade-point average. I think I risk failure every single time with the movies I do, and I haven't fallen into failure."

DERN, BRUCE

Tarantino has worked with the veteran star Bruce Dern three times, on *Django Unchained*, *The Hateful Eight* and *Once Upon a Time ... in Hollywood*. Dern's small role in *Django* was written for him, and he got a bigger showcase in *The Hateful Eight* as a racist but grieving Confederate general, Smithers. In *Once Upon a Time ...*, he was the blind and sickly George Spahn, owner of the movie ranch occupied by the Manson family. That role was originally earmarked for Burt Reynolds, who sadly died just before shooting began. Dern stepped in at short notice. The actor has worked in Hollywood since

SEE ALSO:

Django Unchained

Once Upon a Time ... in Hollywood

The Hateful Eight

1960, really coming into his own at the start of the 1970s with hits including *They Shoot Horses, Don't They?*, *Silent Running*, *The Driver* and *Coming Home*. He named Tarantino as one of the six directorial geniuses he had worked with, along with Elia Kazan, Alfred Hitchcock, Douglas Trumbull, Alexander Payne and Francis Ford Coppola. Keen-eyed fans may also notice that Scoot McNairy appears in *Once Upon a Time...* playing Bruce Dern, playing "Business Bob Gilbert", on the TV show *Lancer*. Dern appeared in the real *Lancer* show twice, though not in the pilot as depicted here. However, uniquely, that makes him a Tarantino character as well as a Tarantino star.

DESPERADO (1995)

SEE ALSO:
Cameos
Rodriguez, Robert

Robert Rodriguez' 1995 sequel to his debut film *El Mariachi* had a vastly expanded budget: not hard, since the first one cost about $9,000. It's half-continuation, half-remake of the first film, with Antonio Banderas now playing the mariachi set on revenge for the murder of his wife. This time he romances Salma Hayek's Carolina while taking on a local drug cartel. Tarantino cameos just over twenty minutes in, playing a gringo "pick-up guy" (his official credit) in town to do business with the big bad (Joaquim de Almeida). He goes into the crudy Tarasco Bar and tells the bartender (Cheech

D

Marin) an off-colour joke. His punchline, however, is interrupted by the sudden shooting of his companion, who apparently didn't pass the security checks. A blood-splattered Tarantino is led off to his meeting just before the arrival of El Mariachi inevitably sparks a gunfight. Naturally, given the timing, his criminal associates assume he had something to do with it and shoot him in the face as he desperately denies involvement. RIP pick-up guy, we hardly knew ye. Still, it's a fun role. The lingering close-ups on Tarantino, and the showcase he's given for his humour, show what a celebrity the director became post *Pulp Fiction*. It's also further evidence that he seems to enjoy being brutally dispatched in his cameo roles.

DESTINY TURNS ON THE RADIO (1995)

This odd 1995 crime caper sees Tarantino play a character literally called Johnny Destiny, who introduces extra chaos into the life of escaped bank robber Julian (Dylan McDermott). It turns out that the mysterious Destiny, a gambler, has stolen the proceeds of Julian's big score and vanished, possibly into a swimming pool portal to the underworld. Tarantino's role is only cameo-sized, but he's front-and-centre of the film's marketing, with a trailer that leans heavily on *Pulp Fiction* to promise

a crime epic it does not deliver. Still, there's a good cast around him that also includes James Le Gros, Nancy Travis, James Belushi, Bobcat Goldthwait and David Cross.

DJANGO & DJANGO (2021)

This documentary by Luca Rea from 2021 is focused on Italian director Sergio Corbucci, but you'd be forgiven for questioning that in its first ten minutes. It opens with animated storyboards of a deleted scene from *Once Upon a Time ... in Hollywood*, narrated by Tarantino. He gives his account of an imagined meeting between his protagonist Rick Dalton and Sergio Corbucci, aka "the second Sergio", (the "first Sergio" was Leone). When Dalton is reduced (as he sees it) to working on spaghetti Westerns after his Hollywood career falters, it's Corbucci that Tarantino imagined as his saviour. After that opening salvo, the documentary skips back and forth through Corbucci's life with extensive contributions from Tarantino on his importance and strengths as a filmmaker, and the themes that can be discerned from his work. Corbucci, who died in 1990, directed films like *Django* and *Navajo Joe*. Tarantino's theory is that all of Corbucci's films were, on some level, about the struggle against totalitarianism, and he develops those ideas alongside library clips of

SEE ALSO:

The Films of Rick Dalton

Once Upon a Time ... in Hollywood

Corbucci himself and interviews with other fans and former collaborators of the director, including Franco Nero (the original Django) and Ruggero Deodato. This is an oddity that, despite the title, is more closely related to *Once Upon a Time...* than *Django Unchained*.

DJANGO UNCHAINED (2012)

Tarantino likes to call his 2012 film a "Southern" rather than a Western. Jamie Foxx stars as Django, an enslaved man freed by bounty hunter King Schultz (Christoph Waltz) because he can help Schultz identify and capture a target. The two men work so well together that they become business partners that winter, hunting down fugitives. But the following spring they go in search of Django's lost wife Broomhilda (Kerry Washington) and learn that she has been taken to Candyland, the plantation of Calvin Candie (Leonardo DiCaprio). He is notoriously reluctant to sell his property, so the two bounty hunters plot to offer a vast sum for one of his "mandingo" fighting men, hoping to slide off with Broomhilda as a small extra. When Candie's conniving head house slave Stephen Warren (Samuel L. Jackson) notices her fondness for Django and gets wise to the scheme, bloody violence erupts. Schultz shoots Candie and is himself slain; Django is briefly taken prisoner and

SEE ALSO:
Academy Awards
Swearing
Waltz, Christoph

D

tortured. But he escapes and destroys Candyland entirely, rescuing Broomhilda and riding off into the sunrise. It's a sprawling, ambitious film, one that aims to condemn the horrors of slavery but also to ridicule the racists who practised it, notably in the "Baghead" scene where a bunch of proto-Klansmen debate their lack of peripheral vision. However, there was controversy at the time over its depiction of slavery, with some critics highlighting both the sadistic violence against slaves and, in other scenes, a strangely relaxed vision of life in bondage. There was also controversy over the script's copious use of the N-word, particularly from Tarantino himself in a small role as a slaver – though his decision to essay an Australian accent was even less popular. That said, the film was generally seen as the full-throated denunciation of racism that Tarantino intended. He told a BAFTA audience that, "We all intellectually 'know' the brutality and inhumanity of slavery, but after you do the research it's no longer intellectual… you feel it in your bones… However bad things get in the movie, a lot worse shit actually happened." The revenge tale made $425 million worldwide, becoming Tarantino's highest-grossing film to date. It also landed five Oscar nominations, including Best Picture, and took home Best Supporting Actor for Waltz and Best Original Screenplay for Tarantino, his second win and first solo win.

DJANGO/ZORRO (2014)

This 2014 comic book by Quentin Tarantino and Matt Wagner, with art by Westerns specialist Esteve Polls, was the first official graphic novel sequel to a Tarantino film. Set several years after the events of *Django Unchained*, this sees Django plying his trade as a bounty hunter in the Western US due to a price on his own head back East. There, he meets Don Diego de la Vega, aka Zorro, and agrees to work as his bodyguard. He slowly realizes that the older man can hold his own in a fight and seems free of the racism that Django has fought elsewhere. Together they battle to save the Indigenous locals from servitude in a continuation of Django's lifelong struggle against slavery. Tarantino has discussed a film adaptation of the series, ideally with Jamie Foxx and Antonio Banderas (star of *The Mask of Zorro* and its sequel) reteaming in the lead roles. In 2019, he had comedy star Jerrod Carmichael (*Poor Things*, *Saturday Night Live*) working on a script for the film, but there's been no confirmation since that it's moving towards production.

SEE ALSO:
Django Unchained

DOUBLE-V VEGA

After *Reservoir Dogs* and *Pulp Fiction*, Tarantino seriously considered making a Vega brothers spin-off starring Michael Madsen as *Dogs*' Vic Vega and

SEE ALSO:
Madsen, Michael
Pulp Fiction
Reservoir Dogs
Ten Movies
Travolta, John

John Travolta as *Pulp*'s Vince Vega. In this prequel concept, Vince moves to Amsterdam to set up a club (he had just returned from that city in *Pulp Fiction*) for crime lord Marsellus Wallace. Vic would visit after leaving prison, and the pair would get into some sort of adventure – Tarantino never decided what – over a weekend. As time went on and the actors aged, it became clear that a prequel wouldn't work. Tarantino then suggested to Madsen that there might have been *four* Vega Brothers – two sets of twins – so that Vic's identical twin and Vince's identical twin could meet again years later and have adventures, but that was far-fetched and perhaps only a joke. Despite the love that the director and both actors have for the characters, this seems unlikely ever to happen – at least in live-action form.

DUCK DODGERS (2003)

If you watched this Daffy Duck cartoon and recognized the voice of the kung fu expert Master Moloch, you're right. It's Tarantino's only credited animation voice role, in the "Master & Disaster" episode (season three, episode eleven). Duck Dodgers, a space duck in the twenty-fourth and a half century, must train with Master Moloch to take down an expert thief known as the Whoosh. The idiotic, blithely confident duck and his more competent pig cadet go through instruction in

SEE ALSO:

Kill Bill: Vol 2

Super Pumped: The Battle for Uber

D the "gibbon hand" martial arts technique with the "monkey guy" master. The villain turns out to be a former star pupil of the Master driven to crime after he got a B- on the course ("Written exam half of final grade, my hands tied," shrugs Moloch). The teacher, with his long, white facial hair, is clearly inspired by Pai Mei in the *Kill Bill* movies, and it proved a chance for Tarantino to play a kung-fu master without enduring months of training. It's fun: Tarantino mimicks the choppy grammar of the dubbed '70s kung fu movies, but, crucially, not the accent.

EDDIE PRESLEY (1992)

Blink and you'll miss this wordless Tarantino cameo, alongside cult star Bruce Campbell, as a psychiatric hospital orderly in this 1992 drama. Directed by horror specialist Jeff Burr (*Leatherface: The Texas Chainsaw Massacre III*), it's based on a one-man show by Duane Whitaker, who stars as Eddie, an Elvis impersonator. He changes his last name to Presley and sells his successful business, determined to go all-in with his tribute act. Alas, things don't quite pan out, and instead he finds himself fired even from a job as a night watchman (by Lawrence Tierney, who would appear in *Reservoir Dogs*). The film's emotional climax sees Eddie bare his soul to an audience in a no-holds-barred, Lenny Bruce-esque rant about the cost of succeeding in showbusiness. Whitaker impressed Tarantino enough that the director hired him for *Pulp Fiction*, where he plays Maynard, the sadistic owner of the pawn shop.

SEE ALSO:
Cameos
Pulp Fiction
Reservoir Dogs
Zed's Dead

E.R. (1995)

While riding high on the success of *Pulp Fiction* in May 1995, Tarantino directed an episode of the hit 1990s hospital drama, titled "Motherhood" (season one, episode twenty-four). It's the one where Dr Susan Lewis (Sherry Stringfield) has to

SEE ALSO:
CSI
Feet

deliver her sister Chloe's (Kathleen Wilhoite) baby, and where Dr Benton (Eriq La Salle) loses his mother. Tarantino was paid $30,000 for the job, a standard TV directing rate at the time that must have seemed like a steal after *Pulp Fiction*'s Oscars success. Tarantino shot in long takes with handheld cameras as much as possible, often doing only one take so that showrunners like John Wells couldn't tweak his preferred version. Supervising producer and episode screenwriter Lydia Woodward included one direct Tarantino reference – a gang member who is brought to the ER after having her ear sliced off – but told *EW* that she also "grossed up" the action to cater to the director's reputation. Hence, perhaps, the teenager impaled by a rebar or the "Little Ranger" scout group suffering from excessive flatulence and vomiting. There are some recognizably Tarantino touches, too. One scene with Lewis and Carol Hathaway (Julianna Margulies) sunbathing on the roof is shot from the feet up, something of a director trademark. On the other hand, this is an episode that delivers genuine emotion and tragedy, in La Salle's heartbroken reaction to his mother's death and Lewis' relationship to her new niece. Tarantino doesn't always get credit for depicting big emotions onscreen, but this shows he's more than capable of it.

EZEKIEL 25:17

SEE ALSO:

Monologuing

Pulp Fiction

There's screenwriting hubris, and then there's rewriting the literal Bible. In the King James Bible, Ezekiel 25:17 reads simply, "And I will execute great vengeance upon them with furious rebukes; and they shall know that I am the LORD, when I shall lay my vengeance upon them." The verse that Samuel L. Jackson's Jules Winnfield recites in *Pulp Fiction* is a) longer and b) a misquote. Rather than reciting 25:16 prior to that finale, Jackson is largely quoting the opening scroll to the 1976 Sonny Chiba movie *The Bodyguard / Karate Kiba* ("The path of the righteous man is beset on all sides by the inequities of the selfish and the tyranny of evil men...") and finishes with a slightly different version of 25:17, one that is again closer to the Sonny Chiba version: "And I will strike down upon thee with great vengeance and furious anger those who attempt to poison and destroy my brothers. And you will know I am the Lord when I lay my vengeance upon you." *Pulp Fiction* made the quote iconic, and it will forever be associated with Jackson. In fact, when his character in the Marvel Cinematic Universe, Colonel Nicholas J. Fury, fakes his own death after the events of *Captain America: The Winter Soldier*, his tombstone reads "The path of the righteous man... Ezekiel 25:17".

F-WORD: SEE SWEARING

FEET

Fans and critics have long speculated that Tarantino has a thing for feet. There are lingering close-ups of women's feet in *Jackie Brown*, *Kill Bill* and *Death Proof*, and in *From Dusk Till Dawn* his character sucks tequila from Salma Hayek's toes. His leading ladies also spend an inordinate amount of time barefoot in *Pulp Fiction*, *Once Upon a Time ... in Hollywood* and *Death Proof*. Not all these shots are necessarily gratuitous. In *Kill Bill: Vol. 1*, for example, Uma Thurman's The Bride stares at her toes, willing them to move, as she attempts to recover control of her body after paralysis. In *Inglourious Basterds*, an examination of Bridget von Hammersmark's (Diane Kruger) feet reveals her collaboration with the Basterds and proves her undoing. Still, the tendency to include foot shots has led some to conclude that Tarantino has a foot fetish. This theory was bolstered by the fact that Tarantino's character in his unfinished directorial debut, *My Best Friend's Birthday*, literally says, "I have a foot fetish" (to be fair, it's the punchline to a joke). However, in his professional career the director shrugged off such speculation, telling *GQ* in 2021 that, "I don't take it seriously. There's a lot of feet in a lot of good directors' movies." He cited

SEE ALSO:

Death Proof
ER
From Dusk Till Dawn
Jackie Brown
Kill Bill: Vol. 1
My Best Friend's Birthday

Alfred Hitchcock and Sofia Coppola as examples of directors who had been similarly accused, and pointed to Luis Buñuel as the person most associated with foot fetishism before Tarantino himself became its poster boy. His words are not, perhaps, a complete denial, but then again feet are a necessary body part so maybe it's all just a coincidence. Even the bit where Stuntman Mike in *Death Proof* just can't stop himself from licking a woman's foot as she sleeps.

THE FILMS OF RICK DALTON

As part of the creation of *Once Upon a Time ... in Hollywood*, Tarantino worked out an unusually complete biography for Leonardo DiCaprio's character Rick Dalton. He wrote a book with details of the actor's life and all his projects, the sort of 1970s film star publication that he grew up reading. Its centrepiece is an imagined Q&A between a young Tarantino and elderly Dalton in 1999, after he meets the by-then retired star at a film festival in Hawaii. The book details films that Dalton appeared in, both real and imagined, and his appearances on TV shows. It covers the years both before and after the events of Tarantino's movie, and the big hit, late in his career, that in the director's mind enabled Dalton to retire in comfort to a tropical paradise. Tarantino has mentioned plans to find time to

SEE ALSO:

Once Upon a Time ... in Hollywood

polish and publish the book, further expanding the *Once Upon a Time ... in Hollywood* universe.

FORREST GUMP (1994)

This is your unfortunate reminder that *Pulp Fiction* was defeated in the Best Picture race not by *The Shawshank Redemption*, or *Quiz Show*, or even *Four Weddings and a Funeral*, but by *Forrest Gump*. *Gump* was the most-nominated film that year and won six Academy Awards in total. It landed Tom Hanks his second consecutive Best Actor Oscar after *Philadelphia*, beating John Travolta, among others. Robert Zemeckis beat Tarantino to Best Director, while Dianne Wiest took Best Supporting Actress for *Bullets Over Broadway* over Uma Thurman. Martin Landau in *Ed Wood* blocked Samuel L. Jackson's hopes. Tarantino and Avary at least took home Best Original Screenplay; *Gump*, happily, was in the Best Adapted category (which it won). For a long time Tarantino believed that if *Pulp Fiction* had been submitted as a comedy at the Golden Globes and had won Best Comedy there, with *Forrest Gump* taking Drama, that would have changed the awards into a two-horse race rather than one where Zemeckis' film was romping home. The *Gump* win is regularly named as one of the great Oscar mistakes, but it's hardly surprising that the generally conservative Academy voters went for a feelgood

SEE ALSO:

Academy Awards

Violence

romp rather than the irreverent, blood-soaked *Pulp Fiction*. Still, history has not been as kind to *Forrest Gump*, while *Pulp Fiction* stands up rather well.

FOUR ROOMS (1995)

SEE ALSO:
Anders, Allison
Rodriguez, Robert

A portmanteau movie hooked around New Year's Eve in a luxurious but faded hotel, this was an experiment: four young up-and-coming directors share a single project. Allison Anders, Alexandre Rockwell, Robert Rodriguez and Tarantino each direct a segment, with the linking device of a newly hired bellhop, Ted (Tim Roth), travelling between the rooms where the four stories take place. Anders' opening segment concerns a coven of witches trying to resurrect their goddess, and the young witch (Ione Skye) who has yet to secure the magic ingredient she needs for the task: semen. Enter the hapless Ted. In Rockwell's story, Ted delivers ice to the wrong room and gets pulled into a violent cheating fantasy at gunpoint. Rodriguez prefigures *Spy Kids* with a story about two children left alone by their mysterious parents (Antonio Banderas and Tamlyn Tomita). Tarantino caps it off with a breezy, talky chapter in the hotel's penthouse. Tarantino plays Chester Rush, a famous director who has just had opened a hit film called *The Wacky Detective*. This motormouth filmmaker, who's obsessed with movie and TV trivia, has a bet going with his friend

Norman (Paul Calderón). If Norman's lighter flicks on ten times in a row, Chester will give him his beloved sports car. If not, Norman will lose a finger – and Ted is paid to wield the cleaver. It's riffing on an episode of *Alfred Hitchcock Presents* called *Man From The South*, which starred Peter Lorre and a pre-fame Steve McQueen (the episode is incorrectly called *The Man From Rio* here). Originally, the twist was that Lorre was a (probable) Nazi and (definite) psycho who collected fingers wherever he went. This time, the twist is that when Norman's lighter fails on the first try, Ted instantly brings down the cleaver, snatches the money and jauntily walks off, escaping the hotel's chaos on the verge of insanity. As the credits roll, the other participants – including a cameoing Bruce Willis – scramble to get Norman and his finger to the hospital. It's a funny, shocking end to a film that otherwise never finds its tone. Anders goes for gentle comedy; Rockwell winds things to a hysterical pitch and Rodriguez never ties his story together (there's a dead body in the bed for… reasons?). Tarantino's segment works as self-parody and as a play on Hitchcock (the same episode inspired a Park Chan-wook segment in portmanteau film *Three… Extremes* ten years later, funnily enough), but is not among his best work. Most distracting of all, Roth's Ted is endlessly twitchy and uneasy, equally out of place in all the situations in which he finds himself. Better think of him as Mr Orange.

FROM DUSK TILL DAWN (1996)

Robert Rodriguez's 1996 hit is an oddity, a built-in double-feature that makes an abrupt switch from crime drama to vampire monster movie about halfway through. The story was conceived by special effects guru Robert Kurtzman; he hired a pre-fame Tarantino to write the script. After their respective successes with *Pulp Fiction* and *Desperado,* Tarantino and his friend Robert Rodriguez were finally able to get the hybrid film up and running. George Clooney, fresh from a gangbuster first season of *ER*, plays the bank robber lead Seth Gecko, with Tarantino as his psychotic brother Richie. After killing a convenience store clerk and Texas Ranger (Michael Parks' Earl McGraw), they hijack the RV of Jacob Fuller (Harvey Keitel), a vacationing preacher who has lost his faith, and take his children (Juliette Lewis and Ernest Liu) hostage. With the family's reluctant help, they cross the border to Mexico and stop in the Titty Twister strip bar to await Seth's contact. He's going to take them to El Rey, the same haven for fugitives that Steve McQueen targeted in *The Getaway*. Just one problem: the bar staff and the strippers are all vampires. As night falls, the film becomes a struggle to survive until morning. Tarantino doesn't make things easy on himself: he plays an incredibly creepy rapist who aspires to his brother's cool control but can never manage

SEE ALSO:
Cameos
ER
Keitel, Harvey
Rodriguez, Robert
Universe, Shared

it. He does, however, give himself a scene with Salma Hayek's stunning exotic dancer Santanico Pandemonium, who pours tequila down her bare leg and has him suck it off her toes. Then she turns into a vampire and bites him, but nobody's perfect. The film was a hit, making $59 million on a $19-million budget and establishing that Clooney had transitioned from successful TV star to big screen idol. It also spawned numerous film and TV sequels and spin-offs, but none shared quite the same sense of shock as that sudden shift midway through this game of two halves.

G

SEE ALSO:

Pitt, Brad

Sundance Film Festival

Thurman, Uma

GILLIAM, TERRY

The former Monty Python star may not be the most obvious influence on Tarantino, since he moved from absurdist comedy into an off-beat Hollywood career and ended up back in indie filmmaking. However, they had a notable meeting when Gilliam was assigned to mentor Tarantino's class at the Sundance Filmmakers Lab. The younger director was about to start *Reservoir Dogs* and worried that he wouldn't be able to put his vision onscreen. Gilliam told him, "Well, Quentin, you don't really have to conjure up your vision. What you have to do is, you just have to know what your vision is, and then you have to hire really talented people, and it's their job to conjure your vision…". This proved to be significant advice for Tarantino going into his first film, and he credited Gilliam for putting his mind at ease at a key career moment. The pair also share similar taste in film stars: Gilliam worked with Uma Thurman (in *The Adventures of Baron Munchausen*), Robert De Niro (in *Brazil*) and Brad Pitt and Bruce Willis (on *12 Monkeys*).

GIRL 6 (1996)

SEE ALSO:

Cameos

Spike Lee's 1996 black comedy follows an aspiring actress, Judy (Theresa Randle), struggling to get her big break. Early in the film she lands a potentially

G

lifechanging audition with a big director, called "QT", played by Tarantino. He acts the sleaze, saying that he's making the "Greatest romantic African-American film ever made, directed by me, of course. The person we're looking for needs to ooze sexuality; can you unbutton your blouse?" Judy reluctantly strips but feels so uncomfortable that she storms out. Her agent (John Turturro in a huge wig) fires her and she resorts to work as a phone sex operator. Known only as "Girl 6", she has considerable success, but when a creepy stalker targets her she moves to LA to restart her acting career. There, another director (Ron Silver) demands that she strip; this time she refuses and keeps her dignity. Tarantino is prominent in the trailer, along with other cameoing stars like Madonna and Naomi Campbell. Critic Roger Ebert described his turn as "continuing his world tour of other directors' movies," which is not inaccurate, but it shows bravery to take such a grotesque part under his own name. It's also unfortunate that Lee shows the audience Judy's breasts, which perhaps undermines the film's moral authority in condemning this sort of #MeToo behaviour.

THE GOLDEN GIRLS (1989)

Think gentle studio sitcoms about older ladies, think Tarantino. *The Golden Girls* was a seven-season mega-hit about four retirees who move to Florida and get in minor scrapes. It starred veteran performers Betty White, Bea Arthur, Rue McClanahan and Estelle Getty. Tarantino's unlikely appearance in "Sophia's Wedding: Part One" (season four, episode six) proved crucial to his career. The episode aired on 15 December 1989, and sees Sophia (Getty) marry Max (Jack Gilford), the widow of her oldest friend. But Rose (White) mixes up a list of Elvis impersonators who might speak at her Elvis fan club with the wedding list, so all the wedding guests are in Elvis drag – including, in a gold jacket in the second row, Tarantino. The director took inspiration from Sun Records-era Elvis for his look and jerky dance moves. Tarantino credited his appearance not to a killer audition but the pompadour he sported at the time. Crucially, the residual payments from this short appearance, and from its recurrence in "clip" episode "The President's Coming: Part 2" (season five, episode twenty-six), helped keep him going as he laboured to make *Reservoir Dogs*.

SEE ALSO:
Cameos
Quiff
Reservoir Dogs

GRINDHOUSE (2007)

SEE ALSO:
Death Proof
Planet Terror
Roth, Eli
Wright, Edgar
Zombie, Rob

Tarantino's *Death Proof* began life as part of this double-feature, recalling the B-movie two-fers of old that ran in "grindhouse" cinemas. These were mostly independent exhibitors who screened exploitation movies, from biker films to zombie movies to borderline (or not so borderline) porn. The golden age of grindhouse ran from the fall of the censorious Hays Code in the early 1960s to the rise of mass-market VHS in the 1980s, though a few cinemas in big cities lasted far longer. Tarantino and his friend Robert Rodriguez happened to own the same lurid grindhouse poster for 1957 films *Dragstrip Girl* and *Rock All Night*. The pair conceived a new double bill: two ninety-minute films back-to-back, with trailers between. *Death Proof* and Rodriguez's *Planet Terror* turned out longer than planned, however, so the pair was split up for their primary release. Later they toured together, accompanied by the specially made trailers from filmmaking friends. Edgar Wright made the Hammer Horror-style trailer "Don't"; Eli Roth shot a trailer for a Black Christmas-esque horror called "Thanksgiving" just after wrapping his *Hostel: Part II*; Rob Zombie contributed "Werewolf Women Of The SS"; Rodriguez made a trailer for a Mexican action movie called *Machete*. That became a real movie in 2010, with a sequel called *Machete Kills* in 2013. *Thanksgiving* also made it to the screen as a

horror hit in 2023. A final trailer that won a South By Southwest competition to be included in the film was added to some screenings. That was *Hobo With A Shotgun*, created by Jason Eisener, John Davies and Rob Cotterill, and Eisener directed that full-length film in 2010. *Grindhouse* therefore became one of the most spun-off conceits in recent Hollywood history, even if it never went on wide release in line with its original plan.

THE HATEFUL EIGHT (2015)

SEE ALSO:
Monologuing
Morricone, Ennio
Richardson, Robert
Swearing

Tarantino's eighth film is his truest Western, a post-US Civil War tale of paranoia and murderous intent in 1877 Wyoming. It follows bounty hunter John "The Hangman" Ruth (Kurt Russell), who's bringing in murderer Daisy Domergue (Jennifer Jason Leigh) to be hanged in Red Rock. He picks up a stranded peer, Major Marquis Warren (Samuel L. Jackson) and the dead bodies Warren intends to claim a bounty against, and later Chris Mannix (Walton Goggins), Red Rock's new sheriff. Snowstorms force a stop at the remote outpost of Minnie's Haberdashery, where they meet cowboy Joe Gage (Michael Madsen), Confederate general Sanford Smithers (Bruce Dern), town hangman Oswaldo Mobray (Tim Roth) and Bob (Demián Bichir), who claims that Minnie left him in charge of the store. An air of general suspicion pervades: Ruth is convinced that at least one of his fellow travellers wants to rescue Daisy, while Warren baits Smithers to pull a gun so he can shoot him dead in revenge for war crimes. But poisoned coffee kills Ruth and innocent coachman O.B. (James Parks), and the revelation that the men who called themselves Gage, Mobray and Bob are members of Daisy's gang – along with her hidden brother Jody (Channing Tatum) – leads to a general shoot-out. The film ends with a fatally wounded Warren and Mannix hanging

Daisy, and waiting to die of their own wounds. It's a story as bleak as the snow outside, with tension as unrelenting as the wind. The explosive violence, when it comes – with fountaining blood and bursting heads – is almost a relief after the slow wind-up. The film contains some of Tarantino's most effectively drawn characters. Ruth has a strict code, something familiar from a thousand Western sheriffs, but he's also casually brutal to Daisy in a way that usually signifies a bad guy. Warren, meanwhile, shows real sadism – but only towards mass murderers. It's a mature approach to what might be termed his heroes. The chewy accents and more florid language of the Western genre allows Tarantino endless linguistic flourishes with just enough swearing so that you know it's him. Perhaps counterintuitively, Tarantino insisted that the film be shot, by the director's regular cinematographer Robert Richardson, on glorious 70mm with refurbished lens once used for 1959's *Ben Hur*. That might seem suited to the vast panoramas of the stagecoach scenes but less essential after, but in fact the huge format gives the film enormous texture and depth of field. Shooting of the exteriors and many interiors took place in Colorado in January 2015 around the preserved Schmid Ranch and on a full-scale set of Minnie's, where snow management costs sent the film $10 million over its $44-million budget. The production wrapped at Red Studios in

LA. Hellbent on authenticity, Tarantino kept the set at a chilly 2°C (35°F) and used real chains for Ruth and Daisy rather than more comfortable rubber ones. Disastrously, the shoot also used a borrowed 1870s Martin guitar which Russell, unaware that it belonged in a museum, smashed against a wall to general horror. There was later an online leak of the film just before release. Nevertheless, it was a critically acclaimed box-office hit. It won composer Ennio Morricone his only competitive Oscar and landed nominations for Jason Leigh and Richardson. Tarantino has since discussed plans to adapt the film for the stage, given that its claustrophobic atmosphere and largely one-room location would seem to be well suited to theatre.

THE HATEFUL EIGHT (LIVE READ)

Tarantino gave the original script for *The Hateful Eight* to a select group of six friends and collaborators who he hoped would take roles in the film. That script leaked in January 2014, appearing on the Gawker sub-site Defamer, and Tarantino cancelled the film. He said that he felt betrayed and depressed by the fact that someone so close to him would allow anyone else – even an agent or manager – to read a script that he had sent in confidence, and that he'd simply publish the script and move on

SEE ALSO:

The Hateful Eight

Wait Until Dark

with another project. To bid farewell to *The Hateful Eight*, Tarantino bowed to public demand enough to stage a live read of the script on 19 April 2014, at the United Artists Theatre in LA. The sell-out crowd saw future cast members, including Samuel L. Jackson, Kurt Russell, Bruce Dern, Tim Roth, Michael Madsen, Walton Goggins, James Parks, Dana Gourrier and Zoë Bell read the script, with Tarantino himself narrating the stage directions. Amber Tamblyn took the Daisy role (Jennifer Jason Leigh was in the audience), and Denis Ménochet and James Remar also took roles. It was at the live read that Tarantino revealed he was still working on the script and had changed the ending (in the live read, Remar's Jody Domergue killed Warren immediately), giving fans hope that the film would happen after all.

HOSTEL (2005)

After the success of his debut film *Cabin Fever* (2002), big studios offered writer-director Eli Roth endless horror remakes, but he was unsure what to do next. He discussed his options with Tarantino, a fan of *Cabin Fever* who had struck up a friendship with his fellow B-movie lover, and listed his ideas. The "sickest", and the one that Tarantino loved, was the concept for *Hostel*, an idea based on a dark-web story about tourists going to Thailand to murder

SEE ALSO:

Feet

Quentin Tarantino Presents

Roth, Eli

Violence

people. Roth began work and considered making it in a pseudo-documentary style, but ended up with a more traditional narrative. Three young men (Jay Hernandez as Paxton, Derek Richardson as Josh and Eythor Gudjonsson as Oli) go to Amsterdam to party. They travel to Slovakia on the advice of a casual acquaintance, who spins tales about a hostel full of beautiful women. They find beautiful girls, but first Oli disappears, then Josh, and then Paxton discovers there are rich businessmen paying locals to abduct tourists they can torture and kill. He survives the night, but escapes with deep physical and mental scars (he's killed at the opening of *Hostel: Part II*). The film was a centrepiece of the "torture porn" genre, revelling in bloody violence and physical dismemberment. It was also a hit, making $82 million on a budget of $4.8 million. Tarantino's name was prominent in the advertising ("Quentin Tarantino Presents, Eli Roth's *Hostel*), and gave this his grindhouse imprimatur: audiences knew they'd be seeing something at least somewhat transgressive. There's even a Tarantino-esque close-up of a woman's beautifully painted toenails, though here her toes are about to be clipped off.

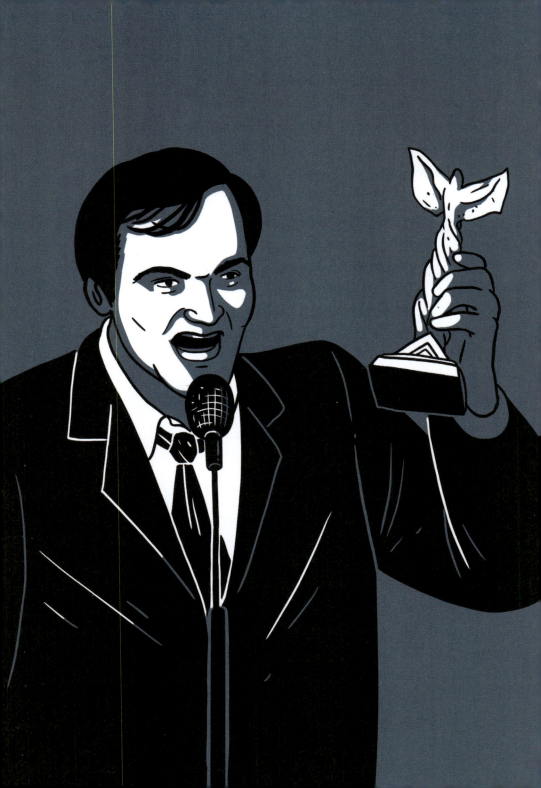

INDEPENDENT SPIRIT AWARDS

The earliest major awards body to support Tarantino was the Independent Spirit Awards, which was almost alone in nominating *Reservoir Dogs* for Best First Feature and Tarantino for Best Director. He won neither – beaten by, respectively, Neal Jimenez and Michael Steinberg for disability drama *The Waterdance*, and Carl Franklin for crime thriller *One False Move* (awards are not the best indicator of lasting popularity). Tarantino returned with *Pulp Fiction* two years later and picked up two prizes for which he was personally nominated. It must have been a clue to the winner of Best Screenplay when his *Pulp Fiction* stars Tim Roth and Amanda Plummer took the stage to present the award. In his acceptance speech Tarantino played down the divide between independent and studio film and emphasized the need to stay true to your own sensibility, whatever the scale. He returned to collect Best Director from Peter Fonda and Diane Ladd, and spent much of his speech geeking out about the reunion of those two stars of 1966 biker movie *Wild Angels*. *Pulp Fiction* also picked up Best Lead Actor for Samuel L. Jackson, and Best Feature, collected by producer Lawrence Bender. It was handily the best haul of the night. Subsequently Tarantino has operated within the studio system, ineligible for Independent Spirit prizes, but he returned there in 2005 as an honorary co-chair alongside Salma Hayek.

SEE ALSO:
Bender, Lawrence
Pulp Fiction
Reservoir Dogs

SEE ALSO:

Inglourious Basterds

Django & Django

THE INGLORIOUS BASTARDS (1978)

Not to be confused with Tarantino's film, this Italian film of 1978 is a loose (and entirely unauthorized) remake of Robert Aldrich's *The Dirty Dozen*. Directed by Enzo G. Castellari, it starred Bo Svenson, Fred Williamson and Peter Hooten as American soldiers sentenced to death. They escape and end up battling Nazis across Occupied France as they try to reach Switzerland. Tarantino liked the title, but his 2009 film is not a remake of Castellari's work. There are, however, references. *Basterds* includes cameos from Svenson as an American colonel and Castellari as a German general. Tarantino never really explained why he misspelled his own title, except to call it "a Quentin Tarantino spelling" and once to refer to it as "an artistic flourish". As a bonus, his unique spelling helps differentiate the two.

SEE ALSO:

Academy Awards

Django Unchained

Once Upon a Time...
In Hollywood

Waltz, Christoph

INGLOURIOUS BASTERDS (2009)

Tarantino's 2009 film is an alternate World War II history with a bombastic finish. The plot concerns opposing forces led by the Nazi "jew hunter", SS Colonel Hans Landa (Christoph Waltz), and American commando Lieutenant Aldo Raine (Brad

Pitt). We meet the former in a bravura opening, where he interrogates a French farmer to learn the hiding place of a Jewish family and ruthlessly execute them. One daughter, Shoshanna (Melanie Laurent), escapes, and years later works as a cinema owner in Paris. Meanwhile, Raine and the titular Basterds arrive in France and set about taking Nazi scalps – literally – and carving a swastika into the forehead of any they spare. These characters find themselves on a collision course when Shoshanna's cinema is chosen for the premiere of a Nazi propaganda film, with Hitler and his high command in attendance. As Raine plots to bomb the cinema with the help of actress Bridget von Hammersmark (Diane Kruger), Landa hunts traitors and Shoshanna plans her own trap for the Nazi elite. It builds to the ultimate crowd-pleasing finale: the execution of Adolf Hitler and all his closest friends. The only downside is that Shoshanna and Bridget lose their lives in the attempt, taken out just before the end by a Nazi war hero (Daniel Brühl) and Landa respectively. Landa tries to negotiate himself a new life in America in return for his agreement not to warn the Nazis about the attack, which he uncovers just in time. However, he's foiled when Raine marks him with a swastika so everyone will know what he is. The film marked a then-box-office high for Tarantino, at $321.4 million worldwide, and landed eight Academy Award nominations.

It also marked two notable new collaborations for Tarantino: Brad Pitt, who would star in *Once Upon a Time... In Hollywood*, and Christoph Waltz, who would enliven *Django Unchained*. Waltz was key here: Tarantino needed someone who could bring his charming, sadistic villain to terrifying life, and in four languages. Waltz won Best Actor at Cannes for the role and subsequently the BAFTA and Oscar. *Basterds* began a new trend in the Tarantino cinematography, an appetite for rewriting history. Tarantino has always been fond of revenge as a motivator for his characters, because he saw it as a relatable human emotion, an effective way to get audiences and their bloodlust on side with a film's heroes. But in *Basterds*, *Django* and *Once Upon a Time...* he showed that revenge doesn't simply have to be a personal mission: he could target real-life monsters, from Nazis to enslavers to serial killers. There's a grand sense of ambition to that that goes far beyond the bloodthirsty karma of a *Kill Bill* or *Death Proof*: now Tarantino is – winkingly, at least – turning the tropes of genre filmmaking against the great wrongs of history. He does so in interesting ways too: the main triggermen here are Roth's "Bear Jew" Donny Donowitz and Shoshanna Dreyfus, two Jewish avengers. Tarantino may still love violence and bad language, but those who dismiss him as an eternally boyish filmmaker should reconsider these recent hits.

JACKIE BROWN (1997)

Perhaps the knives were out for Tarantino when *Jackie Brown* debuted, given his ubiquity after *Pulp Fiction*, but it's the film that was most underestimated in its own time. Happily, it's often cited now as the cineaste's choice of his work. Based on Elmore Leonard's *Rum Punch* in a rare example of a Tarantino adaptation of someone else's story, this is a more mature work about more mature characters. They are still, however, criminals. Jackie Brown (Pam Grier) is a stewardess with a side hustle in transporting money illegally across the border for arms dealer Ordell Robbie (Samuel L. Jackson). When the cops catch her, he uses bail bondsman Max Cherry (Robert Forster) to get her out, and Cherry is instantly fascinated. But Ordell has a habit of killing associates who come under police scrutiny, so Jackie must find a way to keep the police happy and stay out of jail, without arousing Ordell's suspicions that she might turn on him. She and Max concoct a scheme to bring in money and keep it, leaving Ordell to take the fall and powerless to hurt her. Naturally, everything does not go to plan. A few elements have dated – few major motion pictures nowadays would talk so much about a woman being past it at the grand old age of forty-four – but the elegiac quality of Jackie and Max's tentative courtship remains powerful,

SEE ALSO:

Career Resurrections

Jackson, Samuel L.

J

both carrying the sense of decades of regrets. Jackson has rarely been more compelling, though Ordell comes a close second to *Django Unchained*'s Steven for truly repellent characterization (and boasts his worst ever hair and beard). This film also has a supporting cast that would headline any normal movie. Michael Keaton plays ATF agent Ray Nicolette; Chris Tucker is dispatched in one memorable scene, while the great Robert De Niro is Ordell's stoner bestie, alongside Bridget Fonda as Ordell's layabout girlfriend. Tarantino riffs on Grier's blacksploitation films like 1973's *Coffy* in the music, but also positions her drifting through an airport like Dustin Hoffman in *The Graduate*. Like Hoffman, she's a little lost when we meet her, but she figures out a path. And if she doesn't have the self-composure of Foxy Brown, she has the same steel underneath that initially aimless appearance. There's real pleasure in seeing her outwit the forces arrayed against her in an apparently impossible situation. The film picked up one Oscar nomination, for Forster as Best Supporting Actor, and two Golden Globe nods for Grier and Jackson. It was also one of the National Board of Review's ten best films of the year, and *Rolling Stone* in 2022 called it Tarantino's coolest movie. It's interesting to imagine what might have happened if it had been more enthusiastically received on release. Would Tarantino have progressed to his war epic – he was

already writing what would become *Inglourious Basterds* – much sooner? He took six years off after this, and returned with the crowd-pleasing, genre-rooted *Kill Bill* and *Death Proof*. Those might have felt like the safer options after this ambitious, adult film was damned with faint praise.

JACKSON, SAMUEL L.

Perhaps Samuel L. Jackson was destined for A-list stardom: he'd done exceptional work for Spike Lee in the early '90s, winning Best Actor at Cannes for *Jungle Fever*, as well as appearing in *Goodfellas*, *True Romance* and *Jurassic Park*. But Tarantino's *Pulp Fiction* was his star breakthrough, landing him BAFTA and Oscar nominations as Best Supporting Actor. Jackson had auditioned unsuccessfully for *Reservoir Dogs*; when the actor met Tarantino at the premiere and complimented the film, Tarantino said he was writing something for him. The script for *Pulp Fiction* arrived two weeks later. As Jules Winnfield, Jackson was funny, frightening and wildly charming even when shooting up petty criminals or covered in blood. After that performance, Hollywood cast him in everything. He would be nominated for Golden Globes for his work on *A Time to Kill* and in Tarantino's *Jackie Brown*, and stole the screen from sometimes more established stars in films as diverse as *Die Hard with*

SEE ALSO:

Ezekiel 25:17

Girl 6

The Hateful Eight

Monologuing

J

a Vengeance, *The Long Kiss Goodnight*, *Eve's Bayou* and *The Other Guys*. Thanks to his recurring roles in the Marvel Cinematic Universe, *Star Wars* and a series of Tarantino hits, Jackson is the highest-grossing actor in film history, appearing in films that have made an astonishing $27 billion at the worldwide box office. Just as importantly, he forged a successful and lasting relationship with Tarantino. They reteamed five more times with Jackson in *Jackie Brown* as a ruthless arms dealer; *Kill Bill: Vol. 2* cameoing as an organist at The Bride's wedding; *Django Unchained*, as the malignant Stephen; *Inglourious Basterds*, as the Narrator; and *The Hateful Eight*, as a lying bounty hunter. His performances are a big reason why Tarantino's films work as well as they do, but the films have also given him some of his meatiest and most nuanced roles.

KEITEL, HARVEY

Without Harvey Keitel, Tarantino's career would have taken longer to launch. Keitel was the first actor to join *Reservoir Dogs*, and his involvement landed Tarantino the funding he needed to go into production. A New York-born actor, Keitel rose to prominence for his work with Martin Scorsese in the 1970s, notably in *Mean Streets* and *Taxi Driver*. He had a less dazzling 1980s, stereotyped as a thug, but as the '90s dawned he was back on top, with a good supporting role in *Thelma & Louise* and an Oscar nomination for 1991's *Bugsy*. It was therefore a huge deal when he agreed to produce and to play Mr White in *Dogs*, and the sympathetic criminal with a code reminded audiences just how versatile he could be. There's an enormous amount of tenderness in the way he treats Tim Roth's dying Mr Orange, though he could turn on a dime to murderous violence. It proved a key performance in a hot streak. Soon after he worked with Abel Ferrara on *Bad Lieutenant*, Jane Campion on *The Piano* and later Spike Lee for *Clockers*. In between he reunited with Tarantino on *Pulp Fiction*, as Winston "The Wolf" Wolfe, a professional cleaner who scrubs crime scenes – like Vince Vega's car – for other criminals. He's tuxedoed, super-cool and very intimidating to the two hitmen. The character riffed on a role Keitel played in John Badman's

SEE ALSO:

From Dusk Till Dawn

Inglourious Basterds

Reservoir Dogs

Point of No Return the year before, though that was explicitly a hitman. Keitel reprised The Wolf in a series of adverts for UK insurance company Direct Line in 2015, personally asking for Tarantino's sign-off on the concept. The ads were enormously popular, likely because of the affection for *Pulp Fiction*. Keitel also appeared with Tarantino in *From Dusk Till Dawn*, and makes an uncredited phone cameo in *Inglourious Basterds* as an American officer negotiating Landa's surrender with him and then ordering Aldo Raine to deliver him into US custody.

KILL BILL: VOL I (2003)

Tarantino's homage to kung fu movies opens with a Shaw Brothers logo, a tribute to the great Hong Kong film producers, and spends the next two hours delivering something worthy. In a story conceived with Uma Thurman, the *Pulp Fiction* star plays "The Bride", an assassin left for dead by her former colleagues and her boss, Bill (David Carradine). When she wakes from a coma over four years later, she sets about getting revenge. She murders the orderly who was selling her unconscious body to rapists, and teaches herself to walk again. The non-linear narrative sees her go after Vernita Green (Vivica A. Fox) and kill her, though she is unfortunately witnessed by Vernita's young daughter. She also targets assassin-turned-yakuza-boss

SEE ALSO:

Career resurrection

Q&U

Soundtracks

Thurman, Uma

O-Ren Ishii (Lucy Liu). Of course, that involves slicing her way through O-Ren's bodyguards and her "army", the Crazy 88 (actually about forty katana-wielding, black-suited brawlers). To maximize her chances, she goes to legendary sword-maker Hattori Hanzō (Japanese martial arts legend Sonny Chiba) and acquires an impossibly sharp, impossibly strong steel that severs limbs as easily as cutting butter. The Newtonian laws of physics apply only glancingly to her epic battles, as is often the case in kung fu and wuxia movies, and there's even an anime section here to chronicle the backstory of O-Ren Ishii, animated by Production I.G., the legendary studio behind *Ghost in the Shell*. *Kill Bill* was originally planned as a single film, but it became clear that Tarantino would struggle to cut it even to three hours, and would lose many of the grace notes he wanted onscreen. He was persuaded to bisect the film. That allowed him to keep most of the scenes he wanted (the anime section is still only eight minutes long instead of the thirty he originally scripted). As a bonus, it also gave each film a distinct identity, with the iconic yellow tracksuit developed by costume designer Catherine Marie Thomas, now instantly recognizable from Part One and entirely distinct from the little moto jacket The Bride wears for most of Part Two. The music was, as ever, largely chosen by Tarantino himself, but here he brought aboard Wu-Tang Clan's RZA to organize,

produce and orchestrate it to memorable effect. The film made over $180 million worldwide, with five BAFTA nominations and a Golden Globe nod for Thurman as Best Actress. Not bad after she cut the top of someone's head off.

KILL BILL: VOL 2 (2004)

The second half of Tarantino's magnum revenge opus is more Western-tinged than its kung-fu predecessor, but it continues to hop around in time. We meet The Bride – her name now revealed as Beatrix Kiddo – as she drives to kill Bill (David Carradine) but then there's a flashback to show her attempt to kill Budd (Michael Madsen) in his remote trailer outside El Paso. Instead, he captures her and buries her alive. In the coffin she flashes back to her training with Pai Mei (Gordon Liu, who played Crazy 88 leader Johnny Mo in *Vol: 1*), and gains the strength to break free and go after Budd again. But Daryl Hannah's one-eyed Elle Driver gets there first, murdering him with a black mamba snake: the snake that was Beatrix's *nom de assassin*. Beatrix plucks out Elle's remaining eye, leaving her blind and raving in the ruined trailer with a black mamba still loose. Then Beatrix goes after Bill, only to find him with the daughter, BB (Perla Haney-Jardine), that she believed lost when Bill shot her. The little girl calls her mother;

SEE ALSO:
Kill Bill: Vol. 1
Thurman, Uma

Bill has told his daughter all about her comatose parent. Beatrix won't kill him in front of her, leading to a standoff (echoes of Vernita Green) before the final confrontation. Beatrix at last kills Bill using the deadly "five-point palm exploding-heart technique" that Pai Mei taught her and which he denied to Bill. For all the martial arts, however, there's a Western energy to this, from The Searchers-framed shot of The Bride at her wedding rehearsal, standing in the door of a desert chapel, to Bill's distinctly gunslinger attire in his final scenes. Still, it's Tarantino's idea of a Western, so Bill monologues about superheroes too. The Pai Mei scenes give it connective tissue to *Vol. 1*'s homage to kung fu movies, with the same grainy film stock and rain-soaked colours. It's a slower-feeling movie because it finishes with a one-on-one scene between old lovers rather than an all-out battle. Bill is discursive, philosophical, almost charming – but he's so ruthless and so quick to turn on a dime that Beatrix's confrontation with him is incredibly tense. Their duel, when it finally comes, is sudden but seated; there's no time even to stand up and face one another. When he knocks her sword from her hands, she uses the sheath to capture his and delivers the coup de grâce. They even have a moment of reconciliation – kind of – before the fatal blow has its effect. This film develops far more of Beatrix's backstory, and does a far better job of

explaining what brought her into conflict with Bill. It made slightly less money than its predecessor, with $154 million worldwide – but that used to be typical for sequels. For fans of completism, Tarantino edited the two films together in 2011 for *Kill Bill: The Whole Bloody Affair*, which played on tour around the world and at his home base of The New Beverly. But that may not be the end for Beatrix Kiddo…

KILL BILL: VOL. 3

One of the most plausible and longest planned projects on Tarantino's to-do list is a third *Kill Bill*. He talked about it in 2004, and was still talking about it in 2021. There are loose ends that would lend themselves to a sequel: most notably young Nakia "Nikki" Bell (Ambrosia Kelley), daughter of Vivica A. Fox's Vernita Green. She witnessed The Bride execute her mother, and Beatrix Kiddo told her to come have her revenge when she grew up "if you still feel raw about it". The sequel could therefore centre on Nikki's vengeance and might also feature Beatrix's daughter BB, originally played by Perla Haney-Jardine (who had a small role as a drug dealer in *Once Upon a Time… In Hollywood*) though Tarantino has suggested that Thurman's daughter Maya Hawke (who's also in *Once Upon a Time…*) could take the role now, with The Bride

SEE ALSO:
Kill Bill: Vol. 1
Ten Movies
Unmade films
Yuki's Revenge

and BB on the run after twenty years of peace. Darryl Hannah's blind Elle Driver and Julie Dreyfus' armless Sofie Fatale are still out there. Schoolgirl killer and O-Ren bodyguard Gogo Yubari (Chiaki Kuriyama) has a twin sister who could also feature. Given that Tarantino counts the first two parts of *Kill Bill* as one film, it's even possible that he could make this, call it a continuation of the story and not break his ten-film limit.

KILLING ZOE (1993)

Roger Avary's 1993 directorial debut was a Paris-set heist thriller largely filmed in LA. That's because Lawrence Bender, while location scouting for *Reservoir Dogs*, found a bank location he liked and asked if Avary had a screenplay set in a bank. Avary wrote this script in the following two weeks, channelling into it all the nihilism he felt was inherent to his generation. *True Romance* producer Samuel Hadida stepped aboard and Avary cast Eric Stoltz, Jean-Hugues Anglade and Julie Delpy. Stoltz plays Zed, a safecracker brought to Paris by his friend Eric (Anglade) to assist in a Bastille Day bank heist. But when the team are surrounded by police and a gun battle begins, Zed relies on Delpy's Zoe – a bank teller by day and hooker by night – who tries to help when Eric double-crosses him. Tarantino's name featured heavily in the film's

SEE ALSO:

Avary, Roger

Bender, Lawrence

K

trailer, which emphasized the same sort of wild gun violence that audiences already associated with him. The film does share DNA with early Tarantino in its commitment to bloody mayhem, but despite positive buzz at Sundance and Cannes, the critical consensus was not kind, with reviewers finding it all too nihilistic. Still, Avary's stylistic flourishes and the leads' smirking cool won the film a fanbase and established him as a director to watch.

"LIKE A VIRGIN"

Reservoir Dogs starts as shockingly as it means to go on, as Tarantino's Mr Brown waxes lyrical about the "true" meaning of a Madonna classic. "Let me tell you what 'Like A Virgin''s about: it's all about a girl who digs a guy with a big dick. The entire song, it's a metaphor for big dicks." Mr Blonde, of all people, disagrees with this reading in favour of a more innocent take, and the conversation winds away via her song 'True Blue', their feelings about Madonna generally and an old address book that Lawrence Tierney's Joe has been reading. The camera drifts around the table, peering between shoulders from one criminal to the next as Mr Brown tries to pick up the thread, explaining at length the roots of his theory. Tarantino looks shockingly young, grinning broadly at his own outrageousness, but it's an ear-catching start that sets the tone for Tarantino's filmography: funny, willing to shock and always bringing a fresh take on pop culture staples.

SEE ALSO:
Cameos
Reservoir Dogs
Sleep With Me

LITTLE NICKY (2000)

One of Tarantino's most surprising roles came in 2000's Adam Sandler demon comedy, *Little Nicky*. Sandler is Nicky, a son of the devil (Harvey Keitel) sent to Earth to retrieve his wayward brothers (Rhys Ifans, Tom Lister Jr.). Nicky repeatedly

SEE ALSO:
Inglourious Basterds
Roth, Eli

encounters a blind preacher, Deacon (Tarantino), who can sense his demonic presence and goes into a frenzy of spiritual panic whenever he comes near – resulting in a series of impressive pratfalls. Tarantino plays the role at a hysterical pitch; he later said he was inspired by Yosemite Sam. The increasingly crippled Deacon turns up repeatedly because Sandler and director Steven Brill liked the performance so much. They turned the role from fun little cameo – others in the film include Henry Winkler, Ozzy Osbourne, Regis Philbin and Carl Weathers – to running gag. At the time Tarantino was eighteen months into work on the script that became *Inglourious Basterds*, and he wrote the role of the "Bear Jew" for Sandler so they could work together again. Alas, by the time filming began almost a decade later Sandler was busy shooting *Funny People*, so the role went to Eli Roth.

LOVE BIRDS IN BONDAGE (1983)

In 1983, Tarantino worked with aspiring filmmaker Scott Magill on a planned short called *Love Birds in Bondage*. Tarantino was to write and Magill to direct the black comedy. The story concerned a girl who sustains brain damage in a car accident and is institutionalized after exhibiting unpredictable behaviour. Tarantino played her loving boyfriend,

who tries to get himself hospitalized to remain by her side. Alas, the cast list only went as far as Tarantino, who shot a few scenes before filming stalled. The footage was lost: in Magill's account, at his mother's hand; by some suspicions, his own.

LUNDGREN, DOLPH

Few people know that Tarantino's first professional credit was a Dolph Lundgren exercise video in 1987. The fifty-minute-long *Maximum Potential* built on Lundgren's reputation as an action star. A Swedish Fulbright scholar, Lundgren shot to the A-List as bad guy Ivan Drago in 1985's *Rocky IV*, and two years later was preparing his first leading role as He-Man in *Masters of the Universe*. That's when he made an exercise tape, well-established in the wake of Jane Fonda's success as a big money-spinner, cashing in on his enormously muscular shape. The video's disclaimer warns against people "over 35" starting to exercise without advice from a physician, which readers may find depressing, before lingering shots of Lundgren, apparently working as a lifeguard, running in slow motion along Venice Beach (two years before *Baywatch*!). Tarantino and his buddy Roger Avary were hired as production assistants. Their principal duty, as Tarantino remembered it, was clearing dog shit out of the grassy Venice Beach location for the "Stretch" segment of Lundgren's

workout. Tarantino vowed that, if he ever got to direct, he'd help his PAs with similar tasks. He told *Empire* magazine that he made good on that promise by picking up a couple of pieces of dog dirt alongside his own PAs during the production of *Pulp Fiction*.

MADSEN, MICHAEL

After guest roles on TV and working as a mechanic to provide for his young family, Michael Madsen was beginning to gain traction on the big screen at the start of the 1990s. He had small but memorable roles in Oliver Stone's *The Doors* and Ridley Scott's *Thelma & Louise*. But Tarantino's *Reservoir Dogs* catapulted him to a different level. As the sadistic Mr Blonde, he walked away with the film's most talked-about moments – the torture scene, notably – and carved himself into film history. Madsen had concerns about the role, notably the dance to Steeler's Wheel, but his dad dance across the floor, straight razor in hand, proved iconic. In high demand after that for everything from *Donnie Brasco* to *Wyatt Earp* to, er, *Free Willy*, he was not available for *Pulp Fiction*, but he reteamed with Tarantino on *Kill Bill*. There he played Budd, aka Sidewinder, the brother to David Carradine's Bill and the only male member of the Deadly Viper Assassination Squad. He is a relatively sympathetic

SEE ALSO:
Double-V Vega
The Hateful Eight
Reservoir Dogs
Travolta, John

member of the squad – but only relatively. He still buries The Bride alive; he just reckons without her unstoppable will to survive. His next collaboration with Tarantino was *The Hateful Eight*, where he played cowboy and poisoner Joe Gage. Madsen was one of those who received the original script for the film and performed it onstage in its live read before being cast in the film itself. He turns up very briefly in *Once Upon a Time ... in Hollywood*, too, as Sheriff Hackett in *Bounty Law*, the show that starred Leonardo DiCaprio's Rick Dalton.

MENKE, SALLY

SEE ALSO:

Inglourious Basterds
Raskin, Fred

All Tarantino's films from *Reservoir Dogs* to *Inglourious Basterds* were edited by Sally Menke, perhaps his key early collaborator. Menke was almost as new to filmmaking as Tarantino when they worked on *Dogs*; her previous credits included a Griffin Dunne rom-com and Steve Barron's live-action 1990 *Teenage Mutant Ninja Turtles*. The director needed someone cheap for his low-budget film and she, fascinated by the script, was willing and able for it. She proved adept in ensuring that the editing flowed as quickly as his dialogue, and expertly kept the non-linear plates of *Pulp Fiction* spinning. That landed her her first Oscar nomination. *Inglourious Basterds*, and the opening interrogation scene she considered her

finest work, landed her another. She and Tarantino were extremely close: she checked his schedule before agreeing to work with any other director (non-Tarantino projects included Oliver Stone's *Heaven & Earth* and Billy Bob Thornton's *All the Pretty Horses*). He returned the affection, calling her "hands down, my number one collaborator... I write by myself, but when it comes to editing, I write with Sally. It's the true epitome of a collaboration". He would also record greetings of "Hi Sally!" from cast and crew during shooting, to give her a lift when she edited the footage alone later. The pair formed a creative symbiosis that is almost unique in Tarantino's career, and that reflects other director/editor collaborations, particularly Martin Scorsese and Thelma Schoonmaker (who partially inspired Tarantino to consider a female editor). "It's all emotional, impulsive, instinctual," she said of her work. "Just follow the character's emotions." She died in 2010, aged just fifty-six, of heat-related causes after going for a hike on a particularly hot day. On *Django Unchained*, his first film without Menke, Tarantino and editor Fred Raskin had a "WWSD" sign by the AVID editing machine: "What would Sally do?" He told *The Huffington Post*, "I just miss her... more in the last stages of the journey. Those were kind of like the stages – you know, the mix and the color timing and everything – where I would recede just a little bit... she would take one

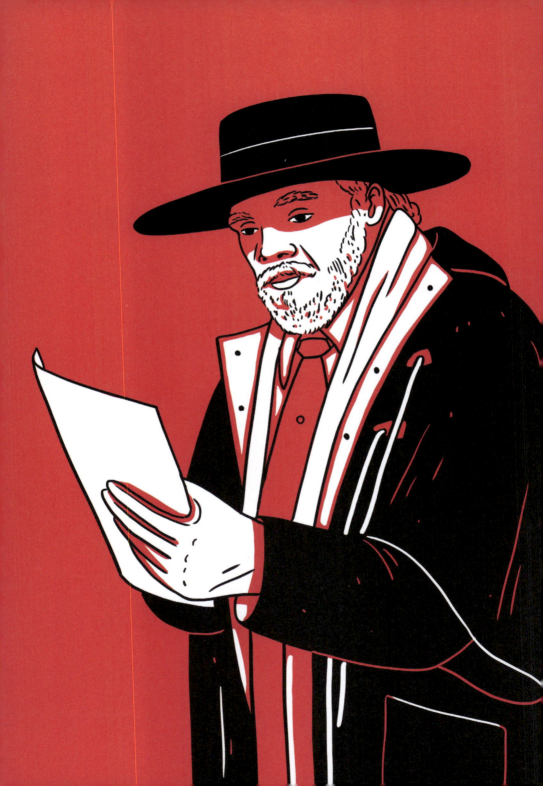

step forward and I would take one tiny step back. And she'd kind of lead the way."

#METOO, SEE *GIRL 6*; WEINSTEIN, HARVEY

MONOLOGUING

"I've missed doing monologues and especially with him because he loves it so much," said Samuel L. Jackson once of Tarantino. "He has a Shakespearean literary prowess tapered for the cinema." Certainly, Tarantino shares the Bard of Avon's taste for long speeches, which might be tiresome if they weren't full of flair and invention. Jackson has delivered several of the best, including *Pulp Fiction*'s Ezekiel 25:17 and *The Hateful Eight*'s Lincoln Letter speech. The fondness for voluminous verbiage could reflect the director himself, with his hyper-verbal disquisitions on all his favourite subjects. Onscreen, through the careful injection of swearing and pop culture references, and with superb actors delivering his lines, these flourishes tend to be cinematic highlights rather than, like other monologues, slowing down the action so that our hero can escape a speechifying villain.

SEE ALSO:

Ezekiel 25:17

MORRICONE, ENNIO

SEE ALSO:
Django Unchained
The Hateful Eight
Inglourious Basterds

The great Italian composer, who died in 2020, established his reputation on the spaghetti Western films of Sergio Leone; most notably *The Good, the Bad and the Ugly*. He built up his career in films like *Days of Heaven*, *The Untouchables*, *The Mission* and *Cinema Paradiso*. But Morricone would deliver excellent late career work for Tarantino. Their association started when Tarantino used existing Morricone music in *Kill Bill* (one track in Part One and three in Part Two) and *Death Proof* ("Paranoia Prima" from *The Cat O' Nine Tails*). It stepped up when the director put eight Morricone tracks on *Inglourious Basterds*, lifting segments from the composer's soundtracks to 1965's *The Return of Ringo*; 1966's *The Big Gundown*; 1966's *The Battle of Algiers*; 1967's *Death Rides a Horse*; 1968's *The Mercenary*; 1973's *Revolver* and 1974's *Allonsanfàn*. For *Django Unchained*, Tarantino got Morricone's permission to use his song "Ancora Qui" ("Still Here"). Their full collaboration arrived on *The Hateful Eight*, Morricone's first Western in thirty-four years. He wrote some fifty minutes of new music for it before he even saw a finished cut, and Tarantino supplemented that with unused tracks the composer had written for *The Thing* in 1982. Their collaboration could be spiky: Morricone repeatedly said that he felt rushed in his work for Tarantino, and one interview claimed that he called the director "absolutely chaotic". However,

Morricone denounced that as a misquote and the publication responsible apologized. *The Hateful Eight* garnered Morricone his first competitive Academy Award for Best Score at the age of eighty-seven. At the ceremony Morricone said, "There is no great soundtrack without a great movie that inspires it. I want to thank Quentin Tarantino for choosing me... and the entire team who made this extraordinary film."

THE MOVIE CRITIC

Tarantino's tenth and theoretically final film was announced in 2023 as *The Movie Critic*, which the director said would be based around a film critic and set in late 1970s LA. The director later explained that his script was based on a male critic who was active but not famous, writing for "a porno rag". He described the man as "very, very funny... very, very rude", which prompted speculation that the character was inspired by critic and provocateur William Margold, who Tarantino mentioned in *Cinema Speculation* and who, ironically, was not a fan of the director. However, Tarantino also said that his inspiration died in his thirties, potentially of alcoholism-related illness, which would demand a younger lead than regular collaborators like Brad Pitt or Leonardo DiCaprio, and which would also seem to rule out Margold. The film was almost

SEE ALSO:
Cinema Speculation
Ten Movies

ready to shoot in 2023 before the SAG-AFTRA strike put it on hold, and in April 2024 the director announced that he was no longer happy with the script and would go back to the drawing board with it; determined, naturally, to finish his career on the highest of high notes. At the time of writing his tenth film and career finale was therefore up in the air once more.

THE MUPPETS' WIZARD OF OZ (2005)

SEE ALSO:

Cameos

Kill Bill: Vol 1

This 2005 TV movie wasn't the best Muppet film, but it's understandable that Tarantino would grab the chance to work with the twentieth century's greatest performer: Kermit the Frog. In this adaptation of *The Wizard of Oz*, Ashanti plays Dorothy Gale and Queen Latifah is Auntie Em, with Kermit as the Scarecrow and Fozzie as the Cowardly, er, Bear. This adventure plays with meta gags, as when they reach the Wizard (Jeffrey Tambor) and find themselves on a Hollywood backlot. Later, as Dorothy prepares to fight the Wicked Witch (Miss Piggy), the scene cuts to Quentin Tarantino, with a chyron calling him "noted action director". He's animatedly pitching a studio exec (Kermit) on an awesome battle involving kung fu, "walking on walls, explosions everywhere, Oz in flames! Burn baby, burn!"

Tarantino is waving a katana the whole time (it was just post-*Kill Bill*) much to Kermie's discomfort. Then he pitches a big finale. "We're talking Piggy transforming into Gonzo, mutating into Scooter, Scooter turning into a big, busty, vampire vixen, who explodes in a sea of crimson blood!" Tarantino cackles maniacally, and then quietly adds, "All done in a classic Japanese anime style. You know, for kids." When Kermit rejects that for budgetary reasons, Tarantino pivots and suggests that Dorothy simply kick Piggy. That is agreed, and the film continues. It's a silly, fun scene and stands up better than most of the film, effectively contrasting Tarantino's reputation as a gore-hound with the endless goofy goodness of the Muppets.

MY BEST FRIEND'S BIRTHDAY (1987)

Tarantino's first directorial effort was a black-and-white film he made with friends in 1987. The script began as thirty or forty pages by Craig Hamann, which Tarantino almost doubled. He recruited four friends, including Roger Avary, as director of photography, the job rotating depending on who was free. The result is inevitably rough around the edges. However, Tarantino's trademark spitfire dialogue, pop-culture riffs and vivid characters are already present and correct, and some of the basic

SEE ALSO:

Love Birds in Bondage

ideas are ones he would revisit in his professional career. Hamann plays Mickey, whose girlfriend has left him. His best friend Clarence (Tarantino), a motormouth radio DJ, plans his birthday present: a date with a call girl called Misty Knight (Crystal Shaw). Alas, his plans go pear-shaped. It's similar to the opening of *True Romance*, though this is played more for laughs. There's also a comic-book reference (Misty Knight is a Marvel heroine), while Clarence claims to be '50s and '60s star Aldo Ray when calling a girl and has a room lined with movie posters: his film fandom is on show already. Tarantino described this as a "Lewis and Martin" thing, though he and Hamann didn't quite reach Jerry Lewis and Dean Martin levels of success. Still, unlike many amateur films it's pacy, funny and has personality. It was intended as a full-length feature, but half of the film was accidentally thrown away (for years Tarantino went along with a story that it was lost in a fire because it sounded cooler). About thirty minutes survive online, making it a fascinating but incomplete portrait of the young Tarantino's promise.

NATURAL BORN KILLERS (1994)

Hyper-stylized and relentlessly paced, Oliver Stone's adaptation of one of Tarantino's earliest scripts dials every element to the max. The account of lovers Mickey (Woody Harrelson) and Mallory (Juliette Lewis) on the run/on a killing spree switches style and music on a dime to put you inside the dizzying experience of being young and psychotic. Mallory's viewpoint is initially played in black-and-white, while Mickey sees things in saturated colour but often at a Dutch angle. A flashback to their first meeting is presented as a TV sitcom, with her abusive father (Rodney Dangerfield) threatening violence to the sound of canned laughter. Flamboyantly mulleted newsman Wayne Gale (Robert Downey Jr.) follows their escapades and elevates them to cult-hero status through his lurid coverage. Even the view out from their motel rooms becomes a psychedelic mix of nature videos and spinning colours. The pair wreak havoc across the US, becoming celebrities due to Gale's coverage before being captured. Then they escape prison, execute Gale and ride off into the sunset to slay happily ever after. Tarantino's script was reworked to such an extent that he ended up with only a "Story by" credit, with Stone, producer Richard Rutowski and *Behind Enemy Lines*

SEE ALSO:

Stone, Oliver

X-rating

screenwriter David Veloz named as screenwriters. Tarantino was disappointed that Stone added a scene where Mickey and Mallory cheat on one another; for Tarantino, as with his *Pulp Fiction* hold-up artists Pumpkin and Honey Bunny, the whole point was that their love was all-consuming. To cheat on one another undermined that. Stone also amped up the film's focus on the media and the public's fascination with violence, inspired by the Rodney King trial, OJ Simpson case and first trial of the Menéndez brothers. It was ironic, then, that the film was seen as glorifying violence in the media rather than condemning it. Four minutes had to be cut to avoid a commercially ruinous NC-17 rating in the US, and in 2010, *Entertainment Weekly* called it one of the ten most controversial films ever made.

NEW BEVERLY CINEMA

As well as being a film fan and filmmaker, Tarantino has been a cinema owner since 2007. The New Beverly was built in 1929, originally as a sweet shop. It became a theatre and later a nightclub, before opening as a cinema in the late 1950s. The cinema has gone through numerous names and identities – operating as a porn cinema in the late 1960s and '70s, for example – but became the New Beverly on 5 May 1978. Under owner Sherman Torgan and his son Michael, it screened a wide variety of double

SEE ALSO:

Grindhouse

Technology

features of classic and modern films. Tarantino became a regular in the '80s, curated a month of double bills there to promote *Grindhouse*, and then set up a monthly donation to keep it going when DVD cut into ticket sales. After Sherman's death, and under threat of closure, Tarantino purchased the property to save it from redevelopment in 2007. Michael Torgan continued to programme for the first seven years of Tarantino's ownership. Then Tarantino took over, promising all 35mm films and no digital projection. "As long as I'm alive, and as long as I'm rich, the New Beverly will be there, showing double features in 35mm," Tarantino told *The Hollywood Reporter*.

NICOLETTE, RAY

In *Jackie Brown*, Michael Keaton plays Ray Nicolette, an ATF officer with unexpected depths. He's drawn straight from Elmore Leonard's novel *Rum Punch*, and recurs across Leonard's work. Notably, he appears briefly in *Out of Sight*, adapted for the screen by Steven Soderbergh. Aware of the character crossover, Soderbergh called Tarantino while *Jackie Brown* was in post-production and asked to see Keaton's work. Impressed, he asked Keaton to come aboard *Out of Sight*. Tarantino persuaded producers Miramax not to charge *Out of Sight*'s studio, Universal, for using the

SEE ALSO:
Jackie Brown
Universe, Shared

character, thereby enabling the crossover without blowing Soderbergh's budget. So Keaton stars alongside Jennifer Lopez and George Clooney in the immensely sexy prison-break thriller, as well as opposite Pam Grier and Robert Forster in Tarantino's insanely cool crime drama. The Ray Nicolette cinematic universe predates Marvel's by a full decade, but he's not quite alone. His *Out of Sight* co-star Paul Calderón (who appears in Tarantino's segment of *Four Rooms*) later pulled off the same trick, playing Raymond Cruz in *Out of Sight* and twenty-five years later in *Justified: The City Primeval*. This presumably means that Timothy Olyphant's Raylan Givens is part of the Tarantino universe, in a roundabout sort of way, and that Keaton could one day show up in *Justified*.

O

OLD CHATTANOOGA: SEE RED APPLE CIGARETTES

ONCE UPON A TIME... IN HOLLYWOOD (FILM) (2019)

SEE ALSO:

Briefcase

The Films of Rick Dalton

Tarantino's 2019 offering is his most ambitious film: a multi-layered, multi-textured look at Hollywood itself and the film and TV stars that he grew up watching. It is also, like *Inglourious Basterds*, a gigantic "what if?". What if the Manson family had not murdered the beautiful, pregnant Sharon Tate in 1969? What if Hollywood had not received that shocking wake-up call from the idealism of the 1960s? That is, at least, the thrust of the plot: Tarantino invents Leonardo DiCaprio's Rick Dalton and Brad Pitt's Cliff Booth and puts them a little farther down Cielo Drive from the Polanski–Tate residence so that they stop the killers dead in their tracks. The film is also an examination of Hollywood and how its ecosystem of fame and fortune works. Rick is a fading star, who's gone from supporting parts in big movies to his own TV show to, now, guesting on other people's. He's offered a lifeline, a chance to star in films made in Italy, but can't figure out if that is a step forward or back. His stuntman Cliff, meanwhile, is beset by the rumour mill of a small town and his inability to get out of his own way. He can't get hired except by Rick, and Rick is not sure he can afford him. Cliff

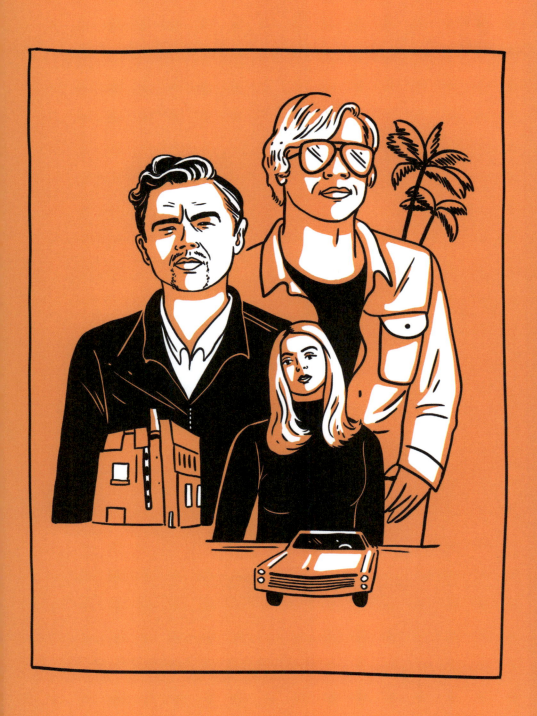

O

also has an odd episode where he gives a hippie hitchhiker (Margaret Qualley) a lift and learns that she's living at the Spahn Movie Ranch, where he used to shoot Rick's hit TV show, *Bounty Law*. Cliff insists on visiting old George Spahn (Bruce Dern) and senses that something is off-kilter. As we now know, it was a Manson family stronghold. After a successful but emotionally draining role on new TV show *Lancer*, Rick agrees to go to Italy, and takes Cliff. When they return they find their home invaded by members of the Manson family led by Tex (Austin Butler), and kill all three of the attackers extremely thoroughly. As an injured Cliff is taken to hospital, Rick is invited to his neighbour Sharon Tate's (Margot Robbie) house to tell her all about it. Cue a happier outlook for the whole industry in a film that's remarkably clear-eyed about the magic and madness of movies. There's a tragedy to Rick's character: his career is fading, and he knows it, and yet he keeps holding on to stardom with all his might. In contrast Sharon, on the verge of superstardom, takes joy in the promise every day seems to hold, still innocent of all the pitfalls that surround her. And Cliff, who never fitted in the first place, seems to be the one who sees it all for what it is – an empty, fun ride. Tarantino's second-highest-grossing film after *Django Unchained*, this benefitted from the star power of DiCaprio, Pitt and Robbie. It was nominated for ten Oscars and won two, for

Pitt's performance and the flawless production design by Barbara Ling and Nancy Haigh.

ONCE UPON A TIME IN HOLLYWOOD (NOVEL)

In June 2021, Tarantino surprised fans with a novelization of his 2019 hit. Naturally, it was an unconventional one. Rather than produce a prose version of the screenplay, he changed the order of his storytelling, added lengthy asides about film and television history, and explored the backstory of certain characters far more than he could onscreen. The film's climactic battle is mentioned off-hand about a third of the way through, while a huge amount of space in the final third is given to the plot and genesis of *Lancer*, the TV show on which Rick Dalton memorably guest-stars (it was a real TV show, where Dalton's role paralleled one played by Joe Don Baker). The book does, however, give a definitive answer to the question of whether Cliff Booth killed his wife (yes) and more background on Charles Manson's obsession with the Polanski house. It also features cameos from the New Beverly Cinema that Tarantino now owns, where Booth goes to watch what he hopes will be a dirty movie, and indirectly a cameo from Tarantino himself. The book finishes with a scene cut from the movie, where Dalton talks on the phone to

SEE ALSO:
The Films of Rick Dalton

Zastoupil, Curtis

O

young Trudi Frazer (Julia Butters) the night before their final scene, and experiences a moment of true appreciation for his life and career in a glorious, healing instant of peace.

OSCARS: SEE ACADEMY AWARDS

PEACE SIGN

In almost every red-carpet photograph, personal appearance and walk onto a stage, Tarantino throws up a peace sign. It's something to do with his hands, a goodwill gesture that's more in keeping with his general philosophy than a simple wave, and a pleasant counterpoint to the violence of his films. He showed it during protests against police violence, and when director Bong Joon-ho thanked him for being an early supporter during his Oscar acceptance speech, Tarantino acknowledged the mention with a peace sign. Tarantino also gave the gesture to Cliff Booth (Brad Pitt) in *Once Upon a Time... In Hollywood*, to a group of hippies. He said that the killer stuntman sincerely means the gesture, so let's assume that the director does too.

SEE ALSO:
Once Upon a Time... In Hollywood
Violence

PITT, BRAD

The role of a seductive grifter in Ridley Scott's *Thelma & Louise* launched Brad Pitt to stardom, but surely he would have got there eventually anyway. His young-Robert-Redford-esque looks soon got him cast by the older Robert Redford in *A River Runs Through It*, and a string of hits from *Interview with the Vampire* to *Fight Club* to *Seven* established him as an A-lister. Along the way he had a hilarious bit as a stoner in *True Romance*, scripted

SEE ALSO:
Inglourious Basterds
Once Upon a Time... In Hollywood

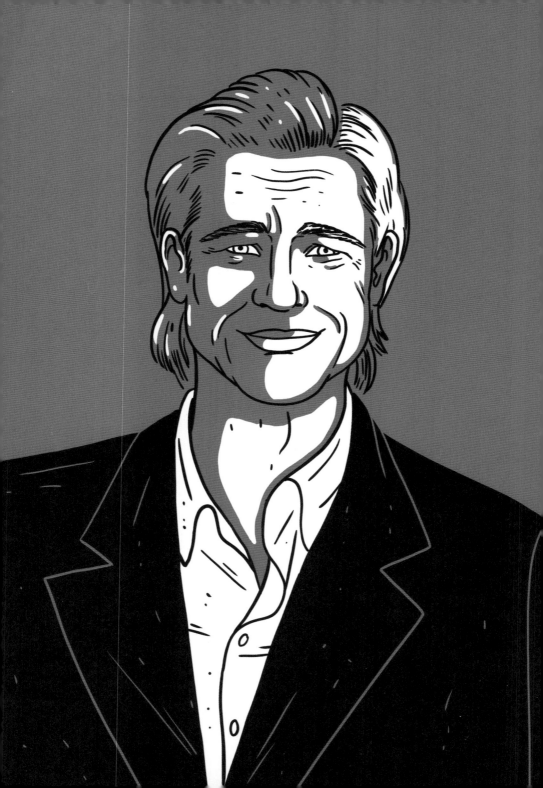

P

by Tarantino, hinting at comedy chops he rarely got to show in his early, superstar years. By the time he first worked with Tarantino on 2009's *Inglourious Basterds* he was transitioning from leading man to leading man-looking character actor, in films like *Burn After Reading* and *The Curious Case Of Benjamin Button*. But *Inglourious Basterds* was a big swing, with Pitt screwing his face into an almost Popeye squint and donning a thick Tennessee accent as a Lt. Aldo Raine, bootlegger turned Nazi scalper. He and Tarantino got along famously, and reunited in 2019 for *Once Upon a Time... In Hollywood*. There, Pitt played stuntman and rumoured murderer Cliff Booth, the platonic life partner of Leonardo DiCaprio's Rick Dalton. Pitt already had an Academy Award for Best Picture as a producer on *12 Years a Slave*, but it won him his first acting Oscar, on his fourth nomination. "This really is about Quentin Tarantino," he said in his speech. "You are original, you are one of a kind, the film industry would be a much dryer place without you, and I love those words you gave Cliff Booth: look for the best in people. Expect the worst, but look for the best."

PLANET TERROR (2007)

Robert Rodriguez directed *Planet Terror* for his 2007 *Grindhouse* collaboration with Tarantino,

SEE ALSO:

Death Proof

Grindhouse

Parks, Michael

Universe, Shared

complete with a trailer for the (then) imaginary Danny Trejo film, *Machete*. *Planet Terror* itself is a gonzo zombie movie made grindhouse style, with scratches on the most eye-catching scenes – as if those had been rewound and played over and over – and a missing reel, skipping the entire second act where the disparate good guys have to assemble in one location. Broadly, the story concerns a gas that turns people into boil-covered, flesh-crazed zombies or "sickos". Go-go dancer Cherry Darling (Rose McGowan) loses a leg in the chaos, but must hobble along so she can lead a ragtag band of survivors to safety with her ex, El Wray (Freddy Rodriguez). Bruce Willis leads the soldiers who released the gas and are now micro-dosing to manage their symptoms; *Lost*'s Naveen Andrews is the biochemist who invented it; Josh Brolin plays a hospital doctor and domestic abuser who falls victim, with Marley Shelton as his wife. Michael Parks returns once more as Earl McGraw (here we learn that his wife, ill with cancer, died of this zombie gas), while James Cameron regular Michael Biehn plays Sheriff Hague. It's spectacularly gory, Rodriguez leaning fully into the grindhouse aesthetic. That's particularly true in Tarantino's cameo as a soldier whose infection runs out of control and whose dick falls off in a shower of slime as he's about to rape Cherry. He's stabbed through the eye by her makeshift pegleg (she later dons

P

a machine gun prosthetic) and shot in the head. Tarantino also cameos as a zombie-eating roadkill and spent a lot of time on the set, to the extent that Shelton said he "really co-directed." However, this bears many Rodriguez trademarks, like the acting role for Tom Savini, a run for the Mexican border and jokes about Texas barbecue.

PULP FICTION (1994)

Pulp Fiction began life scavenged from the best bits of scripts that Tarantino had developed with Roger Avary, redrafted and stitched together in a daring, non-linear form that interwove brilliant lines and memorable characters in ways no one expected. When Tristar, where Tarantino had a filmmaking deal, put the film in turnaround, Harvey Weinstein and Miramax snatched it up and committed to its $8.5-million budget. It was a good investment: it became the first indie film to break $100 million in the US and grossed over $200 million worldwide. Author Peter Biskind described it as "the *Star Wars* of independents," the film that upended commercial expectations for every indie that followed. Its tangled narrative is sometimes described as circular, though it hops around a lot and weaves together a huge cast. Chronologically, it goes like this: two hitmen, Vince Vega (John Travolta) and Jules Winnfield (Samuel L. Jackson)

SEE ALSO:

Avary, Roger

Briefcase

Weinstein, Harvey

retrieve a briefcase belonging to their boss, Marsellus Wallace (Ving Rhames) from a small-time drug dealer. After killing most of the people in the apartment and miraculously surviving a shooting at point-blank range, they bring one survivor to apologize to Marsellus. Alas, Vince accidentally shoots their hostage in the car. They go to clean up at the house of a friend, Jimmy (Tarantino), with the help of fixer The Wolf (Harvey Keitel), and then pause for breakfast at a diner, which is held up by Pumpkin (Tim Roth) and Honey Bunny (Amanda Plummer). Jules manages to talk the two to a standstill as things threaten to get violent, thanks to a newfound determination to live a good life (and by threatening them with Marsellus' displeasure). The hitmen then deliver the briefcase, while their boss is telling boxer Butch (Bruce Willis) that he must take a dive in a match that night in return for a pay-off. Instead, Butch bets the cash on himself and attempts to flee the city after accidentally killing his opponent. Alas, his girlfriend Fabienne (Maria de Medeiros) has forgotten his gold watch, a family heirloom brought back from Vietnam by his father's fellow prisoner Captain Koons (Christopher Walken). Meanwhile, Vince takes Marsellus' wife Mia (Uma Thurman) out – but she accidentally overdoses on heroin and he has to revive her with a shot of adrenaline to the heart, with the help of dealer Lance (Eric Stoltz). The following day, as

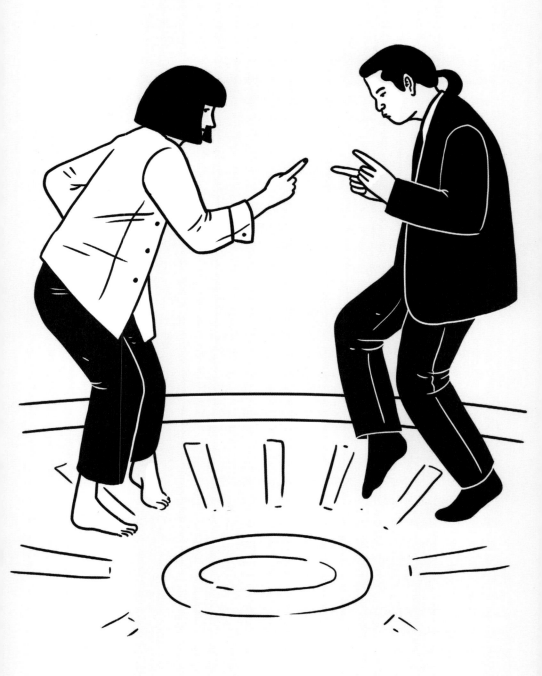

Butch tries to retrieve his watch, he finds Vince in his house and shoots him dead, and then crashes his car into Marsellus while driving away. The two, both injured, stagger into a pawn shop and are taken prisoner by the sadistic owners. Butch frees himself while they rape Marsellus and then goes back to help the mob boss, who, in return, allows him to live. That's a bare-bones narrative; what makes *Pulp Fiction* special is the distinct feel of the vignettes, the crackling dialogue ("I'm sorry, did I break your concentration??") and indelible personalities. After the only moderate success of *Reservoir Dogs* at the US box office, this established Tarantino overnight as a star director in the model of Steven Spielberg or Alfred Hitchcock. Reviewers hailed it as something special, marrying pulpy characters, shocking B-movie violence and a cheeky sense of humour (and fondness for bad language) that scandalized the uptight. The time-hopping narrative required a little more concentration than the films that inspired it, and allowed Tarantino to show a finesse and ambition that many of his pulp predecessors lacked. Bruce Willis demonstrated his acting ability at the height of his stardom, while Jackson and Thurman became stars overnight and Travolta rejoined the top echelons of Hollywood. No wonder it has been much imitated but never equalled in the thirty years since.

SEE ALSO:
Kill Bill: Vol. 1
Pulp Fiction

Q & U

The credit for the story of *Kill Bill* (both parts) and for the character of The Bride goes to "Q&U", aka Quentin Tarantino and Uma Thurman. The pair worked together on *Pulp Fiction*, where Thurman's Mia Wallace was the star of a cancelled TV show called *Fox Force Five*. She and Tarantino discussed that show and the idea of doing a movie based on a similar premise: five deadly assassins working together. It took nearly ten years to make, by which time Thurman was a mother – which shaped the characterization of The Bride and the story of *Kill Bill*.

QT8 (2019)

Filmmaker Tara Wood chronicled Tarantino's career to date in this 2019 documentary. Wood specializes in filmmaker documentaries: she also completed *21 Years: Richard Linklater*, in 2014, and plans an upcoming film on Tim Burton. But rather than talk to Tarantino, who hardly needs an intermediary, she went to his collaborators for their insights into his working methods and priorities. There, she got extraordinary cooperation and enthusiasm for the subject, from peers like Eli Roth and cast members like Tim Roth and Michael Madsen. Wood divides her documentary into chapters, Tarantino style,

Q

with loads of visual flair to mimic her subject's style. The film is also peppered with Tarantino quotes and presented in a non-linear way, as with many of his stories. There are uniquely charming anecdotes about filming for Tarantino, too: Michael Madsen talks about giving Tim Roth a hug on *Reservoir Dogs* and getting stuck together with all their fake blood. It's an affectionate and fascinating look at the first eight films; Tarantino himself seems to have enjoyed it.

QT FESTS

In the 1990s Tarantino made regular trips to Austin, Texas, to hang out with his friend Robert Rodriguez and *his* friends Richard Linklater and Mike Judge, the core of a small but vibrant local filmmaking scene. From 1996 the Austin Film Society that Linklater had founded hosted this event with Tarantino. Informally at first, the "QT Fest", or Quentin Tarantino Film Festival if you're not into the whole brevity thing, ran six times until 2006. There, he would celebrate obscure movies and B-list actors from his vast collection of film history, using his own star power to draw people in. Some of his films were relatively well known – 1973's *The Three Musketeers*, *Star Trek II: The Wrath of Khan*, *For a Few Dollars More* – while some were particular favourites of the director, like *Vanishing Point* (a big touchstone for *Death Proof*), *Navajo Joe* and *Rolling*

SEE ALSO:

Rodriguez, Robert

Rolling Thunder

Thunder. There were obscure efforts featuring future stars, like *BMX Bandits* (an early Nicole Kidman film) and *The Savage Seven* (starring future director Penny Marshall). You can also see Tarantino bringing along films that influenced his work-in-progress, like *Switchblade Sisters*, an influence on *Kill Bill*, or Italian war movies like *From Hell to Victory* that he watched for *Inglourious Basterds*. Not all of the films were what you'd call lost greats, but collectively they offer a fascinating insight into his tastes.

QUENTIN TARANTINO PRESENTS

Since Tarantino became an established name, he has used his star power to promote other people's work. Sometimes he's been actively involved in their development – think *Hostel* – while some he simply enjoyed. Films to carry the "Quentin Tarantino Presents" moniker include Zhang Yimou's *Hero*, which Tarantino helped launch to Western audiences, and veteran star Larry Bishop's *Hell Ride*, which Bishop wrote and directed as well as starring alongside Tarantino favourites like Michael Madsen. Others have been less successful: he was an executive producer on the well-meaning Johnny Knoxville bomb *Daltry Calhoun*, and the direct-to-DVD Scott Spiegel film *My Name Is Modesty*, a Modesty Blaize prequel. Many of the releases from

SEE ALSO:

A Band Apart

Hostel

Rolling Thunder Pictures

Q

his Rolling Thunder Pictures also came with the "presents" card, though it was by no means exclusive to those releases. While you can see through-lines to his own films, he's moved away from the "Presents" credit after some disappointing efforts.

QUIFF

Pictures of Quentin Tarantino as a very young man show him with an unruly mop, but in the '80s his Elvis fandom led him to style a swooping quiff. The 'do helped him land a role in *The Golden Girls* that would enable him to stay afloat while he wrote the scripts that would be his breakthroughs. No haircut, maybe no career. He kept the quiff through *Reservoir Dogs*, and it persists in rather shaggier form in *Pulp Fiction*.

SEE ALSO:

The Golden Girls

RASKIN, FRED

What do three *Fast & Furious* movies and Quentin Tarantino have in common? Editor Fred Raskin. Raskin was an assistant editor on Paul Thomas Anderson's *Boogie Nights* and Christopher Nolan's *Insomnia*, and two little films called *Kill Bill*. He stepped up to full editor in 2006 with Justin Lin's *Annapolis* and worked on three *Fast & Furious* films, among others. He then forged a successful working relationship with director James Gunn on three *Guardians of the Galaxy* movies and the TV show *Peacemaker*. Raskin started editing for Tarantino on *Django Unchained* after the death of Sally Menke. The pair quickly found their groove, perhaps helped by the fact that the *Django* post-production was highly pressurized to meet a planned Christmas release. They reteamed on *The Hateful Eight* and *Once Upon a Time... In Hollywood*, and Raskin earned BAFTA nominations on *Django* and *Once Upon a Time....* Raskin has described their process as about 70 per cent work, 30 per cent talking about movies.

SEE ALSO:
Django Unchained
The Hateful Eight
Menke, Sally
Once Upon a Time... In Hollywood

RED APPLE CIGARETTES

Tarantino set several early scripts in Denny's, a US breakfast restaurant chain where he spent a lot of his twenties. However, the brand refused permission for him to use their name given his

SEE ALSO:
The Films of Rick Dalton
Rodriguez, Robert
Rolling Thunder

films' violence, so he found independent diners for *Reservoir Dogs* and *Pulp Fiction*. With controversy about violence a perpetual career theme, Tarantino quickly realized this would be a recurring problem and started creating fake brands like Red Apple Cigarettes, Big Kahuna Burgers and Cabo Air. His friends used them too. Robert Rodriguez featured Red Apple in both *From Dusk Till Dawn* and *Planet Terror*. The cigarette brand even shows up in *Romy and Michele's High School Reunion*, starring Tarantino's then-girlfriend Mira Sorvino. Acuna Boys, named after a gang in Tarantino's beloved *Rolling Thunder*, shows up as a Tex-Mex food brand in *Jackie Brown* and *Death Proof* and, as the name of a gang, in *Kill Bill: Vol 2*. Big Kahuna first appears in *Reservoir Dogs* but pops up in *Pulp Fiction*, *Four Rooms*, *From Dusk Till Dawn*, *Death Proof*, *Romy and Michele* again, *Once Upon a Time... In Hollywood* and even Rodriguez' *The Adventures of Sharkboy and Lavagirl*. In *Once Upon a Time...*, Rick Dalton is a spokesman for Red Apple (Tarantino makes a voice cameo directing his ad spot). Not only did these fake brands mean that there were no legal issues to be negotiated, but they became Easter eggs for fans to seek out from film to film.

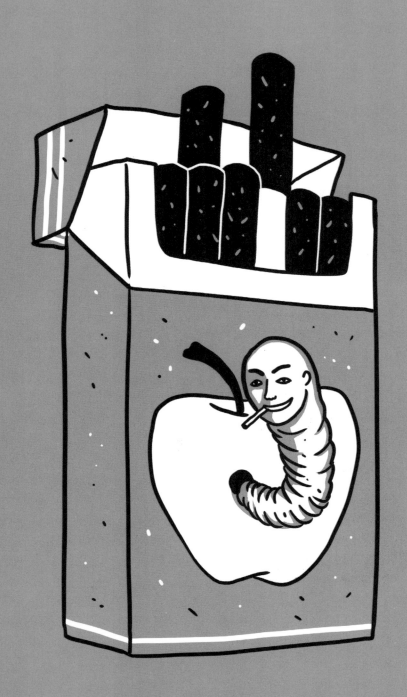

"RESERVOIR CATS" (2011)

Season eight, episode thirteen of *The Simpsons*, called Simpsoncalifragilisticexpiala(Annoyed Grunt)cious, features a lengthy Tarantino homage. *The Simpsons*' cartoon-within-a-cartoon, *The Itchy & Scratchy Show*, runs "Reservoir Cats", an episode "guest directed" by Tarantino. The mouse Itchy, in a black suit, has Scratchy the cat tied to a chair, and pours petrol around him as "Stuck In The Middle With You" plays. As he threatens the quaking Scratchy with a straight razor in an homage to *Reservoir Dogs*, the director jumps in. "What I'm trying to say in this cartoon is that violence is everywhere in our society. You know, it's like, even in breakfast cereals, man." Itchy slices off Tarantino's head with the straight razor, Scratchy breaks his bonds and they twist to a song reminiscent of "Misirlou", from the *Pulp Fiction* soundtrack. Tarantino didn't play himself, unusually; he's voiced by Dan Castellaneta. According to producer Al Jean he simply didn't fancy that dialogue. He has, however, been filmed wearing a T-shirt with his Simpsons' character, so he didn't seem offended by his yellow alter-ego.

SEE ALSO:

Girl 6

The Muppet Wizard of Oz

Reservoir Dogs

Saturday Night Live

RESERVOIR DOGS (1992)

SEE ALSO:

Cameos

Gilliam, Terry

Keitel, Harvey

Tarantino's debut marked the arrival of a major talent. On its face, it's a simple crime drama: a crew of five strangers rob a diamond wholesaler. The heist goes wrong and the survivors must manage the fallout. Mr White (Harvey Keitel) is the old pro, and the relatively sympathetic one; Mr Blonde (Michael Madsen) is the uncontrollable psycho; Mr Pink (Steve Buscemi) is twitchy and paranoid; Mr Orange (Tim Roth) is dying slowly of a gunshot to the gut – and worse, he's the undercover cop who sold the team out, which could lead to him dying very, very fast if Mr Blonde finds out. Tarantino stages the preparation for the robbery and its bloody aftermath – though not necessarily in that order – but largely skips the event itself. Instead, he shows an early preference for focusing on the bits that other crime dramas miss. Mercifully, he drops in a few explanatory flashbacks, handily introduced by the title cards that he would continue to use. So as the team reassemble at their warehouse rendezvous, he builds in glimpses of the past that explain how this motley crew met and what each wants. The flashbacks show us that Mr Blonde, aka Vic Vega, is fanatically loyal to team boss Joe Cabot (Lawrence Tierney) so we know Joe and his son, Nice Guy Eddie (Chris Penn), won't believe Mr Orange's claim that Blonde was going

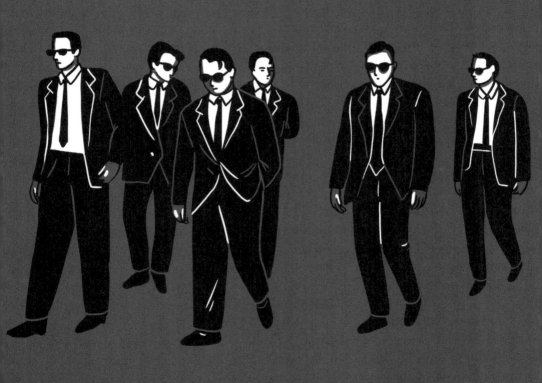

to betray them. Tarantino showed a witty eye for detail, too: the wrapped bundles in one corner of the warehouse rendezvous point are coffins, just enough for the crew. The film was so low-budget that the cast had to wear their own black suits (look closely and you'll see Steve Buscemi is in black jeans, not suit trousers). But for all the limitations on the first-time filmmaker, Tarantino knew what he was doing. The near-single location script gave him wiggle room to spend money on his cast and focus on character, something that would prove far more effective than any high-octane robbery scene could have done. He recruited Keitel – who also co-produced – for established star-power, and the rising stars of Madsen, Buscemi and Roth to bolster him. Lawrence Tierney and Eddie Bunker added the weight of long-time bruisers to proceedings: Bunker was a convicted felon before he went straight and started writing crime novels, while Tierney was a famous brawler. Tarantino himself chose to play the slightly geeky wise guy and – in something that would become a pattern – to die early on. Then he orchestrated a shocking amount of violence, from the copious blood loss of Mr Orange's wounds to the cop who loses an ear to the final bloodbath. That turned some audiences off, sure, but it meant that others couldn't stop talking about this gonzo new movie. The difference with Tarantino is how he combined a B-movie sensibility, embracing

violence and shock, with an A-list sense of where the camera should be, how the film should be cast and, above all, how a script should be written. That sharpness set his film apart from what went before and from its many, many imitators. Contrary to how it feels looking back, however, *Reservoir Dogs* was not a monster hit. It made only $2.8 million at the US box office: not bad for a budget of only $1.2 million, but no juggernaut. The fact that it made considerably more in the UK proves how slow America was to realize what they had, and the film's strong performance since shows that it only needed to find its audience.

RICHARDSON, ROBERT

Cinematographer Robert Richardson has won the Academy Award for Best Cinematography three times, for *JFK*, *The Aviator* and *Hugo*. He began his career with three consecutive films for Oliver Stone – *Platoon*, *Salvador* and *Wall Street* – and worked with the director eleven times in total. He also had a fruitful collaboration with Martin Scorsese on *Casino*, *Bringing Out the Dead*, *The Aviator*, *Shutter Island* and *Hugo*. Since teaming with Tarantino on *Kill Bill*, he has shot every Tarantino film, and been Oscar-nominated for four of them. Richardson has called Tarantino "the closest collaborator I've been with in many years" while Tarantino joked that their

SEE ALSO:

The Hateful Eight

Menke, Sally

Raskin, Fred

Technology

relationship was his "first marriage". The pair share a respect for shooting on film, saturated colour and the importance of collaborating closely with cast members. Tarantino will show Richardson his scripts sometimes months before shooting – before even casting the film – and prepares detailed shot lists for key scenes in advance. It's a relationship that has only grown stronger, with Tarantino disputing Richardson's suggestions less and less over the years and Richardson developing huge respect for Tarantino's clear vision.

RODRIGUEZ, ROBERT

SEE ALSO:
Desperado
Four Rooms
Grindhouse
Planet Terror
Sin City

One of Tarantino's closest professional relationships is unquestionably with Robert Rodriguez. The Austin-based filmmaker broke through with *El Mariachi* in 1992, a violent tale of revenge shot on a shoestring budget where Rodriguez was writer, director, producer, editor and cinematographer, and which he funded by volunteering for medical testing. That put him on the debut director circuit in the same year that Tarantino was launching *Reservoir Dogs*, and the two quickly bonded. They each directed a segment of 1994's *Four Rooms* and Tarantino cameoed in Rodriguez' sequel to *El Mariachi*, the bigger-budget, starrier *Desperado* in 1995. The two collaborated again on *From Dusk Till Dawn*, with

Tarantino writing and starring for Rodriguez. For much of the 1990s Tarantino was a regular visitor to Rodriguez's home base in Austin, staging his QT Film Fest there. Rodriguez quit studio work after 1998's *The Faculty,* subsequently setting himself up as an independent filmmaker in Austin, developing his own franchises (*Spy Kids*) rather than taking further studio work. This was partly because he resigned from the Directors Guild of America so that he could credit comic book author Frank Miller as co-director on his ultra-faithful 2005 adaptation of *Sin City* (and its 2014 sequel). But Rodriguez and Tarantino continued to collaborate. Tarantino shot a short segment of *Sin City*, and the pair shared *Grindhouse* duties when Rodriguez made the zombie(ish) movie *Planet Terror* to sit alongside Tarantino's *Death Proof*. While Rodriguez, a father of five, has a more PG-friendly filmography than Tarantino, with five *Spy Kids* films plus *The Adventures of Sharkboy and Lavagirl* and *We Can Be Heroes*, in the right project, such as *Planet Terror*, he shares Tarantino's fondness for blood and gore. He also continues his *El Mariachi* habit of working multiple roles, often credited as editor, composer and/or cinematographer as well as director. The *Planet Terror* credit that lists him as his own chef is perhaps a jokey reference to his propensity to do it all – but then again, maybe not.

SEE ALSO:

Cinema Speculation

Kill Bill

Red Apple Cigarettes

Rolling Thunder Pictures

SEE ALSO:

A Band Apart

Quentin Tarantino Presents

Video Archives (shop)

ROLLING THUNDER (1977)

Tarantino may be the world's biggest fan of John Flynn's *Rolling Thunder*, a film he saw in 1977 as a teen, that stayed with him ever since. It's a revenge tale from a story by Paul *"Taxi Driver"* Schrader. William Devane stars as Charles Rane, a POW released after seven years in captivity. He's struggling to readjust when his home is invaded by the Acuna Boys, looking to steal the silver dollars he was awarded to mark his courage. They destroy his hand in a garbage disposal to try to make him reveal where the coins are, and then shoot Rane, his wife and son. He survives; they do not – and when he later identifies the men, he and old war buddy Vohden (Tommy Lee Jones) brutally hunt them down. It contains many of the themes that would preoccupy the adult Tarantino, notably the satisfactions and pitfalls of revenge; the difficulty of reconciling a history of violence with a family and home; and the joy of a tooling up scene. No wonder he "followed it all over Los Angeles" in the '70s, as he says in *Cinema Speculation*, desperate to see it again and again before home video made that easy.

ROLLING THUNDER PICTURES

In 1995, Tarantino opened a distribution company under the Miramax banner with Jerry Martinez,

a former Video Archives colleague turned graphic designer. They planned to release "films that might not otherwise find a distributor," Martinez told the *LA Times* in March 1996. According to him, Tarantino is "not a figurehead. Every little decision, including art and ad work, is funnelled through him." The company released Wong Kar-Wai's glorious *Chungking Express*, but their other re-releases were less critically acclaimed and not financially successful: *Detroit 9000*, *The Mighty Peking Man*, *Sonatine*, *The Beyond* and *Switchblade Sisters*. Indie films *Hard Core Logo* and *Curdled* also failed to find an audience. The label was essentially mothballed in 1999, though Tarantino briefly revived it for three re-issues, with Miramax and Lionsgate, around the time of *Django Unchained*.

ROTH, ELI

A friend and collaborator of Tarantino's, Eli Roth shared his fondness for gore and audience provocation. Roth's student film, *Restaurant Dogs*, was a barmy fantasy homage to *Reservoir Dogs* where a young man must save the "Dairy Queen" from an evil Ronald McDonald. Tarantino became a Roth fan after seeing 2002's *Cabin Fever*, one of his favourites that year. The two collaborated on *Hostel* and its sequel, which paid off with two box-office successes on which Tarantino served as executive producer

SEE ALSO:
Death Proof
Grindhouse
Hostel
Inglourious Basterds

and lent his name with a "Presented by" title card. Roth later made cannibal movie *The Green Inferno*, a remake of *Death Wish* and children's horror *The House with a Clock in Its Walls*. In 2023, he released *Thanksgiving*, based on the fake trailer he created for *Grindhouse*. He also took a small role in *Death Proof* and starred as "The Bear Jew", Donny Donowitz, in Tarantino's *Inglourious Basterds*. During his downtime on that set he shot the propaganda-film-within-a-film of *Stolz der Nation* (aka *Nation's Pride*). It stars Daniel Bruhl's Fredrick Zoller as himself, an unstoppable sniper taking out whole battalions of Americans in Italy. Roth stages some fun moments even in his short film, having Zoller idly carving a swastika in the floor during his lunch break, and referencing *Battleship Potemkin*'s famous Odessa Steps sequence when a baby's pram rolls into the middle of the gun battle.

ROTH, TIM

With a limited budget on *Reservoir Dogs*, Tarantino needed rising but not established stars. Tim Roth was perfect, just coming off the breakthrough double-whammy of Tom Stoppard's *Rosencrantz and Guildenstern Are Dead* and Robert Altman's Van Gogh biopic, *Vincent & Theo*. Roth loved the script. He immediately warmed to the layers of Mr Orange, being a Brit playing an American and a cop

SEE ALSO:
Four Rooms
The Hateful Eight
Pulp Fiction
Reservoir Dogs
Universe, Shared

playing a robber. As the almost-hero of the piece he was a hugely sympathetic presence. Months later, Roth told Tarantino that he'd like to work with Amanda Plummer "as long as she has a big fuckin' gun". Tarantino said, "Done" and presented Roth and Plummer with Pumpkin and Honey Bunny, their stick-up-artist lovebirds in *Pulp Fiction*. Roth also played bellhop Ted in *Four Rooms*, the linking character before the film's four disparate parts. The director and star next reunited on *The Hateful Eight*, where Roth played Oswaldo Mobray, aka gang member "English" Pete Hicox. He was also a butler in *Once Upon a Time... In Hollywood*, but sadly his scene was cut from the theatrical release. Elsewhere, Roth earned a BAFTA award and Oscar nomination for his role in *Rob Roy* in 1995, played a monster in *The Incredible Hulk* and was an evil chimpanzee in Tim Burton's *Planet of the Apes*. Maybe that's easier than bleeding to death as Mr Orange.

RUM PUNCH

Elmore Leonard's 1992 novel differs in key respects from its film adaptation, *Jackie Brown*. For one, the novel's heroine is a white woman called Jackie Burke, not a Black woman called Brown, and for another, the action is set in Florida rather than Tarantino's native LA. Tarantino had long been

SEE ALSO:

Jackie Brown

Nicolette, Ray

a Leonard fan and read the book prior to release. He once described *True Romance* as his attempt at a Leonard novel, with all its vividly realized characters shooting the shit while doing crime. At that time he couldn't give Leonard's publishers the assurances they wanted and assumed he had missed his window, but he got another chance following *Pulp Fiction*. He spent about a year adapting just the first hour of the film, playing with dialogue and character. Tarantino knew he needed to focus less on story and more on people, ultimately making one of the most successful Leonard adaptations to date and the author's favourite.

RUSSELL, KURT

A professional actor since the age of twelve, Kurt Russell began work in the title role of TV Western series *The Travels of Jaimie McPheeters*, alongside Charles Bronson. He then spent ten years under contract to Disney, gamely starring in movies like *The Computer Wore Tennis Shoes*. Russell reinvented himself as the 1980s began, however, with a great performance in TV film *Elvis* and a Golden Globe nomination for Mike Nichols' *Silkwood*. Perhaps more importantly – certainly for Tarantino's fandom – he formed a professional relationship with John Carpenter that led to a string of wildly charismatic, unspeakably cool performances in

SEE ALSO:
Death Proof
The Hateful Eight
Once Upon a Time... In Hollywood

R

The Thing, Escape From New York, Big Trouble in Little China and later *Escape from LA*. If anything, it's a wonder that Tarantino and Russell didn't hook up sooner. When they did collaborate on *Death Proof* the mutual admiration was real: Russell called Tarantino the "Professor of Directology". They reteamed twice more, on *The Hateful Eight* and *Once Upon a Time… In Hollywood* – or perhaps three more times, since on the latter Russell plays both stunt coordinator Randy Miller and the film's narrator. Tarantino credited Russell as a huge help because he worked on shows like *Lancer*, much like the film's Trudi, and could check Tarantino's authenticity on small details.

SATURDAY NIGHT LIVE

You know Tarantino is a big deal because he's the only auteur to have hosted *Saturday Night Live* solely because on his directing credentials and not because he's also a movie star (like George Clooney, Ben Affleck or Ron Howard). He hosted on 11 November 1995, and his monologue concerned "the greatest moment in TV history" – which he named as an episode of *Bewitched*. He then performed a song from that episode, "I'll Blow You A Kiss In The Wind", with Elvis-style dancing and enormous enthusiasm. His sketches were a mixed bag. "Leg Up" is a fun pastiche of old Hollywood chat shows, while "Directors On Directors" had Tarantino interviewing other filmmakers about whether they'd slept with their leads. It's an uncomfortable watch post-#MeToo, though the butt of the joke is obviously meant to be Tarantino's creepy host. The sketch "All Aboard" has Tarantino playing on his reputation for extreme violence as Chester Millbrush, a model train enthusiast who boasts about murdering endless "hobos" (including postmen). "Campfire" makes fun of his bloodsplatter, with exploding beer cans and gore-filled mosquitos. None are all-time greats, but Tarantino acquits himself perfectly well. His episode was also notable as the first appearance of Norm MacDonald's long-running Stan Hooper character,

SEE ALSO:

Girl 6

Reservoir Cats

S

and of Will Ferrell and Cheri Oteri's cheerleader sketch, both of which feature Tarantino in small roles. In addition to hosting *SNL*, incidentally, Tarantino has also been parodied on it, played by MacDonald in 1998 and Fred Armisen in 2003.

SHE'S FUNNY THAT WAY (2014)

SEE ALSO:

Cameos

Girl 6

Peter Bogdanovich's 2014 comedy was an attempt to get back to the screwball success of his films like *What's Up, Doc?* Owen Wilson plays a successful Broadway director who falls for a call girl, Izzy (Imogen Poots), and funds her quest to become an actress. Romantic shenanigans ensue, with virtually every man Izzy meets becoming obsessed with her. In a coda we learn that she does indeed become a star and is dating Quentin Tarantino. He agreed to cameo because he's fan of Bogdanovich's films, particularly *They All Laughed*, and as a chance to work with the older director. The result was a nostalgic throwback, though unfortunately reviewers didn't find it funny that way and audiences didn't find it at all.

SIN CITY (2005)

SEE ALSO:

Richardson, Robert

Rodriguez, Robert

Technology

Robert Rodriguez's and Frank Miller's *Sin City* film attempted something remarkable: an almost

totally faithful adaptation of a heavily stylized, mostly black-and-white comic. Rodriguez and his co-director Miller recruited a vast and wildly talented cast, and in some cases (Mickey Rourke, Benicio del Toro) rendered them almost unrecognizable under prosthetics that matched their comic-book incarnations. Tarantino was intrigued by Rodriguez' ambitious plan to shoot the entire thing digitally and create a world from scratch, sometimes before cast members had even been selected. He directed a segment wherein Dwight (Clive Owen) drives to a Tar Pit while holding an imaginary conversation with the recently deceased "Iron Jack" Rafferty (del Toro), whose body he's about to dump. As primary-coloured lights flicker across their black-and-white faces, Dwight has to reckon with a near-empty gas tank and the motorcycle cop who's about to pull him over. Soon afterwards Tarantino said that he enjoyed the experience of shooting on digital and planned to use it again, but he has continued to use film since. In 2022 Tarantino told *The Howard Stern Show* that, "I've never really been a big 'do a bunch of special effects later' kind of guy. I come from the idea that if you didn't shoot it on the day, it doesn't count." His *Sin City* scenes therefore stand out in his filmography, a digital one-off that may never be repeated.

SLEEP WITH ME (1994)

It's testament to the power of a good cameo that this 1994 relationship drama, which played to some acclaim at the Cannes Film Festival, is now chiefly remembered for Quentin Tarantino's one-scene turn. The focus is meant to be the marriage of Meg Tilly and Eric Stoltz's characters, and the complicating factor that she might also be in love with their best man (Craig Sheffer). However, the most famous scene now is Tarantino's turn as Sid, a party guest who waxes lyrical on the homoerotic subtext of *Top Gun*: "subversion on a massive level" as he sees it. He contends the action classic is about a man battling his homosexuality, until the end (which Tarantino renders as "You can ride my tail any time" rather than "You can be my wingman") shows that he has given up the fight. This was a party piece of performative argument that Tarantino used to do with Roger Avary, and it proved wildly popular and enduring. *Top Gun* producer Jerry Bruckheimer was asked about the theory when promoting *Top Gun: Maverick* in 2021 and told *Vulture* that, "People can interpret it in any way that they want… Coming from Quentin, it's always a compliment."

SEE ALSO:
Cameos
Cannes Film Festival
"Like a Virgin"
Monologuing

S

SEE ALSO:

Cinema Speculation

Django Unchained

Jackie Brown

Kill Bill: Vol 1

Morricone, Ennio

Once Upon a Time… In Hollywood

Pulp Fiction

Reservoir Dogs

SOUNDTRACKS

As well as a deep knowledge of movie history, Tarantino has a sharp ear for music. Over the course of his career, Tarantino films have relaunched forgotten songs and artists to the top of the charts. The *Reservoir Dogs* soundtrack sold over a million copies; *Pulp Fiction* would dwarf that number. It was almost impossible in the 1990s to go to any student bar and *not* hear one or both records. Perhaps his needle drops work so well because he makes his playlists as he writes. He conceives of characters and situations alongside music to match, browsing his record collection until he finds something that feels right for the story he's writing – especially the opening credits. He considered "Misirlou" by Dick Dale & The Del Tones, used on the opening credits of *Pulp Fiction*, a way to throw down the gauntlet to himself and the audience, because it felt both intense and epic, something for the movie to deliver on. In *Cinema Speculation* he describes his musical preference as "'50s rock 'n' roll and '70s soul". That's the basis for many of his choices, though not all. In his period films, he doesn't hesitate to pull from later eras where he feels it's warranted. *Once Upon a Time… In Hollywood* is soaked in the music of its late '60s period, but *Django Unchained* gleefully makes use of anachronistic flourishes

like a James Brown/Tupac mix of "The Payback/ Untouchable". The lengthy use of "Across 110th Street" by Bobby Womack for the opening of *Jackie Brown* feels entirely proper for the character, something she would listen to, but the ahistoric use of David Bowie's "Cat People (Putting Out Fires)" fits equally well with Shoshanna's preparations for revenge in *Inglourious Basterds*. Tarantino soundtracks are also notable for the imitations they inspired. "Surf music" briefly became extremely popular because of its association with the cool of *Pulp Fiction*; "Battle Without Honor or Humanity" from *Kill Bill: Vol 1* became the only possible choice for a tooling-up or pre-battle team-up scene in films from *Kung Fu Panda* to *Team America: World Police*. It's hard to say if the success of his films has popularized his soundtrack choices or vice versa, but the impact is undeniable.

STAR TREK

It seems improbable, but for a brief, shining moment in 2017 it looked as though Quentin Tarantino might make a *Star Trek* film. The maverick director successfully pitched a new concept to Paramount Studios and producer JJ Abrams, and worked to develop a shooting script. His idea was, reportedly, loosely inspired by the original series episode "A Piece Of The Action",

SEE ALSO:
Bond, James
Ten Movies
Unmade films

S

which was set on an alien planet whose entire culture was built on 1920s Earth gangster stories. In Tarantino's R-rated vision, the crew of the starship *Enterprise* would actually time-travel back to 1930s Earth and face off against gangsters before making their way home. Tarantino, a fan of Abrams' 2009 *Star Trek* film and its cast – led by Chris Pine as Captain Kirk and Zachary Quinto as Lt Spock – envisioned it as a sequel to that movie, and worked with screenwriter Mark L. Smith (*The Revenant*) to develop a full script while he finished work on *Once Upon a Time... In Hollywood*. However, the film never came to pass. With nine films in the can, Tarantino didn't necessarily want to direct a franchise effort as his tenth and final offering, and Paramount may have developed cold feet when faced with the prospect of a sweary, violent *Trek* without the superstar director at the helm. Or it may simply be that reassembling the now A-list cast proved too great a challenge. Either way, the film seems unlikely ever to get out of space dock.

STEVEN SPIELBERG'S DIRECTOR'S CHAIR

Surely one of the oddest entries on Tarantino's CV is this 1996 video game. It's a movie-making simulator, with directorial legend Steven Spielberg appearing to give the player pep talks and advice

S

as they try to make a film. The player starts with a small budget and an assistant and must parlay that into a successful feature. Tarantino stars in the in-game movie (actually directed by Spielberg). He is a convict on death row who is facing execution for the murder of an old lady. His only hope is his loyal girlfriend (Jennifer Aniston) who is trying to find missing evidence on the real killers, played by Penn & Teller. The player can get advice from luminaries like editor Michael Kahn, special effects supervisor Michael Lantieri, and cinematographer Dean Cundey, but not reshoot the footage. That's the game's major drawback: limited options and finite material. Call it a meta commentary on filmmaking in the studio system. Still, Tarantino has fun hamming it up as the desperate inmate who, in one version of the story, takes his guards and the prison chaplain hostage to give Aniston's plucky detective time to figure things out. There's even a *Reservoir Dogs* poster on the wall of his cell just to remind you how star-stuffed this game is.

STONE, OLIVER

The relationship between Tarantino and director Oliver Stone, the man behind *Platoon*, *Wall Street* and *W*, is often called a "feud". That seems a bit strong, however, for two filmmakers who basically disagree over one film. Tarantino felt

SEE ALSO:

Natural Born Killers

that his script for *Natural Born Killers*, which Stone directed after Warner Bros bought his screenplay, contained everything a director could need. Stone, however, wanted to change it up and add lengthy meditations on the intersection of violence and the media. As a result, Tarantino received only a "story by" credit and did not support the film wholeheartedly through the years. He objected to it being rewritten, hated the sitcom parody scenes establishing Mallory's backstory and disliked the moment where the two lovers cheat on one another. Tarantino politely wished the film well on release but has said since that he has never watched it the whole way through. Stone, meanwhile, felt that Tarantino's criticisms hurt the film with both critics and audiences. Admittedly, Tarantino did once say, "If you like my stuff, don't watch that movie", but he also claimed in 2007 that he and Stone had made peace, so any animosity seems to have died.

SUKIYAKI WESTERN DJANGO (2007)

The first *Django* film Tarantino appeared in was this 2007 English-language effort from the Japanese director Takashi Miike. Tarantino plays legendary gunslinger Piringo, seen in the opening scene shooting a bird from the sky that has just snared a snake, then slicing a chicken egg from the snake's

SEE ALSO:

Cameos

Django & Django

Django Unchained

S

gullet. He proceeds to explain the film's premise of a gang war, in an ol' timey Western accent and an ill-advised, vaguely Japanese one, to some bandits he then shoots dead. After that he muddles his egg and uses it as a dip for his sukiyaki (a type of hot pot stew). He later appears in heavy aging prosthetics. Alas, the film was not a runaway success. Miike, the brilliant director behind *Ichi The Killer* and *Audition* – Tarantino called him "one of the greatest directors living today" in the trailer – did not speak English, nor did most of the cast, and their phonetic dialogue is distracting. The wild hodgepodge of samurai, Western and apocalyptic tropes also didn't help. Still, this boasts spectacular action scenes, wild swings, and arguably Tarantino's coolest cameo.

SUNDANCE FILM FESTIVAL

The Sundance Film Festival takes place every January in Park City, Utah, with a focus on showcasing American-made, independent film. Founded in 1978, it came into its own in the late 1980s and early 1990s with the emergence of stars like Steven Soderbergh, Allison Anders and, of course, Tarantino. It has continued to help launch modern greats like Marielle Heller, Ryan Coogler and Gina Prince-Bythewood. Tarantino attended the Sundance Writer's Lab, a workshop for

SEE ALSO:

Gilliam, Terry

Reservoir Dogs

Violence

S

up-and-coming filmmakers, in 1991 on the strength of his *Reservoir Dogs* script – which was due to start shooting days after his return from Utah. But it was *Dogs*' debut the following year that caused a real stir. The film was far more violent and genre-leaning than the typical Sundance art film, prompting concerns that the festival had strayed from its core mission in programming it. However, it proved a sensation, and if it didn't win any prizes Tarantino's ascendency with *Pulp Fiction* only helped the festival's reputation for spotting new talent. Sundance was suddenly the place that produced the superstar Tarantino, not only the indie darling Soderbergh. Many would-be Tarantinos followed in *Dogs*' wake. Kevin Smith was one beneficiary, another fast-talking writer-director who cameos in his own films, and later genre hits like *Saw* would premiere at the festival, widening its appeal to new audiences.

SUPER PUMPED: THE BATTLE FOR UBER (2022)

In another example of Tarantino's fandoms leading him to unexpected places, he acted as Narrator for season one of this anthology show. Based on the non-fiction book by Mike Isaac, *Super Pumped* focused on ride-sharing app Uber, from its huge initial success to the public embarrassment of

SEE ALSO:
Alias
CSI
Q&U
Thurman, Uma

S

CEO Travis Kalanick (Joseph Gordon-Levitt) being ousted in a boardroom coup after allegations of irresponsible behaviour. Tarantino is a fan of the TV show *Billions*, starring Damian Lewis (Steve McQueen in *Once Upon a Time... In Hollywood*), and *Super Pumped* shares the same showrunners, Brian Koppelman and David Levien. Koppelman invited Tarantino to act as narrator while inviting him onto his *The Moment* podcast, and the filmmaker agreed to both requests. As narrator he's not overused, adding a little (sometimes sweary) punctuation to the tale of wheeling, dealing and boardroom violence, but it's an interesting change of pace. It's also another sort-of collaboration with Uma Thurman, who plays journalist Arianna Huffington.

SWEARING

Tarantino and swearing go together like strawberries and fuckin' cream. Across nine films, there are over 1,900 instances of swear words, racial and sexual epithets and general bad language. The *Dallas Observer* counted them and found over 260 uses of "fuck" (including variations like "motherfucker") in *Reservoir Dogs* and in *Pulp Fiction*. After that he calmed down somewhat, but "fuck" has still cropped up an impressive 901 times in total. "Shit" managed only 295 times, a poor showing by comparison. Most controversially, he used the N-word heavily,

SEE ALSO:
Monologuing
X-rating

S

especially in his near-US Civil War adventures of *Django Unchained* and *The Hateful Eight*. His argument, essentially, is that the word was less taboo in those times than in our own and that it was necessary to convey the levels of racism that the characters played by Jamie Foxx, Kerry Washington, Samuel L. Jackson, etc. faced. The N-word was used 110 times in the former film and 47 in the latter. Tarantino has, over the years, sometimes argued for his 'right' to use the N-word based on a childhood surrounded by Black family members and schoolfriends, but now seems to have accepted that the word is not one that people want to hear from him – certainly outside of a historical context. In terms of more general swearing, however, he remains a poet of profanity who uses bad language in a way that is both big *and* clever.

TATE, SHARON

The most famous of the Manson family victims was the young, beautiful Sharon Tate, heavily pregnant when she was murdered. In Tarantino's *Once Upon a Time... In Hollywood*, as played by Margot Robbie, Tate survives because the Manson Family killers are intercepted by Rick Dalton and Cliff Booth, but otherwise her depiction is largely accurate. She really was generally hailed as a sunny, loveable person whose stardom was still developing. Tarantino shows that in an interesting way, however. While he reshoots real TV episodes like *Lancer* to insert Rick Dalton, and even imagines Dalton in the Steve McQueen role in *The Great Escape*, he shows the real Sharon in her film *The Wrecking Crew*. His fake Sharon, Margot Robbie, watches Tate from a cinema seat. It's a bold swing, but Robbie resembles Tate enough that the effect is not too discombobulating, and it's a lovely tribute to the starlet whose life was cut so tragically short.

SEE ALSO:
The Films of Rick Dalton
Once Upon a Time... In Hollywood

TECHNOLOGY

Tarantino is not a tech enthusiast. He writes his script drafts in long-hand, using cheap Bic or Flair pens, and he doesn't like email, preferring an old-fashioned cassette-tape answering machine. On his sets, mobile phones are completely banned,

SEE ALSO:
Richardson, Robert
Sin City
Video Archives (shop)

and Tarantino won't use a video monitor or video village; he prefers to sit next to the camera and keep track of his (film, not digital) shots the old-fashioned way. He is also a strong proponent of film projection over digital, describing the latter as "television in the cinema"; he has a cinema in his Beverly Hills home. In everyday life he uses streaming services but prefers physical media. As well as buying up the Video Archives inventory when that shop closed down, he owns a vast collection of VHS, DVD, Laser discs, Blu-rays and 35mm prints, as well as a huge array of posters and film memorabilia.

"TELEPHONE"

The video for this Lady Gaga / Beyoncé hit of January 2010 features *Kill Bill*'s Pussy Wagon, which Tarantino now owns. Gaga and Tarantino were mutual fans, and over lunch in 2009 she explained her concept for the "Telephone" video to him: Beyoncé's slightly dom character would bail Gaga's lady murderer out of prison (following the video for Gaga's "Paparazzi") and they would escape into the desert, before murdering Beyoncé's misogynistic boyfriend (Tyrese) and half a diner full of people. Tarantino suggested the Pussy Wagon for the shoot, and Gaga leapt at the offer. There's also an echo of *Pulp Fiction* in the video's dialogue:

SEE ALSO:

A Band Apart

Kill Bill: Vol. 1

Pulp Fiction

Gaga calls Beyoncé Honey B, a reference to Amanda Plummer's Honey Bunny. Tarantino still has the Pussy Wagon but rarely drives it because, obviously, it's rather recognizable.

TEN MOVIES

Tarantino told *Playboy* in 2012, and multiple interviewers since, that he intends to stop making films after his tenth movie or after turning sixty (which he did in 2023). In 2015, he told *Deadline* that, "I don't believe you should stay onstage until people are begging you to get off… directing is a young man's game… It's not etched in stone, but that is the plan. If, later on, I come across a good movie, I won't not do it just because I said I wouldn't. But ten and done, leaving them wanting more — that sounds right." This unusual plan for a short filmography and relatively early retirement reflects Tarantino's focus on his career as a whole. He told *Playboy* that, "Usually the worst films in [a director's] filmography are those last four at the end. I am all about my filmography, and one bad film fucks up three good ones." Better, in his mind, to bow out at the top of his game, and avoid any trailing off. By counting *Kill Bill* as one movie and not including the portmanteau movie *Four Rooms*, he has one final film to go. He plans to spend the rest of his days writing novels or writing and

SEE ALSO:

The Hateful Eight (live read)

Kill Bill: Vol. 3

The Movie Critic

SEE ALSO:

Crimson Tide

directing for the stage. Whether he can be persuaded to do a Soderbergh and unretire, thanks to late career masterpieces by filmmakers like Martin Scorsese and Hayao Miyazaki, remains to be seen.

THE ROCK (1996)

Despite being uncredited, it's an open secret that Tarantino did rewrite work on Michael Bay's Alcatraz-set action classic. The film stars Nicolas Cage as Stanley Goodspeed, a technician who must infiltrate a terrorist-occupied Alcatraz to defuse chemical weapons with the help of the only man ever to escape the prison, British spy John Mason (Sean Connery). Cue odd-couple chemistry and a brutal battle to save not just hostages on the island but the whole of San Francisco. Proof that Tarantino was involved? Early on the geeky Goodspeed receives an order of rare vinyl and waxes lyrical about his musical opinions. He engages in creative swearing ("How in the name of Zeus' butthole…") and nerdy kiss-off lines ("It's you, you're the Rocket Man") and seems like an obvious candidate for the Tarantino touch, though the director has never confirmed his work here. Incidentally, he wasn't the only A-list screenwriter/director to have ghostwritten on the film: Aaron *"The West Wing"* Sorkin also did a pass. No wonder it's so zingy.

THURMAN, UMA

Uma Thurman broke through on the big screen in 1988 while still a teenager, starring as a naked Aphrodite emerging from the waters in Terry Gilliam's *The Adventures of Baron Munchausen* and playing the small but eye-catching role of Cécile in Stephen Frears' *Dangerous Liaisons*. She showed similar boldness throughout the early '90s, appearing in films like *Henry & June*, which nearly landed an NC-17 rating for its sexual content. It should then come as no surprise that she worked with Tarantino on *Pulp Fiction*, taking the role of mobster's wife Mia Wallace and dominating the film's iconic poster as Mia with her black bobbed wig, red lipstick and cigarette. She and Tarantino struck it off, starting a discussion on set that would eventually lead to the conception of *Kill Bill*. Thurman spent months training in kung fu immediately post-partum to prepare for that role, but suffered her worst injury on the shoot when she was asked to drive a large old car that careened off a dirt road and into a tree. The actress suffered damage to her knees and back that, she said in 2018, continued to trouble her. She didn't feel that Tarantino had given her enough support during that incident and it led to a rift; he later called her accident "the biggest regret of my life". The two did bury the hatchet, however, and seem open

SEE ALSO:

Kill Bill: Vol. 1

Pulp Fiction

to working together again, making possible a *Kill Bill: Vol. 3*. Since 2004, Thurman played on her *Kill Bill* action credentials in films like *My Super Ex-Girlfriend* and, more recently, *The Old Guard* sequel. She hasn't always had the roles to showcase her talent, but her work with Tarantino shows that she's capable of greatness.

TIERNEY, LAWRENCE

The veteran character actor Lawrence Tierney played the title role in 1945's gangster movie *Dillinger*, and began a lifelong association with onscreen violence. To be fair to his casting directors, Tierney had a similar energy off-screen, with a string of arrests for drunk and disorderly conduct. Tarantino hired him to play crime lord Joe Cabot in *Reservoir Dogs*, trading on his long career with a line about someone being "dead as Dillinger". However, the debutant director didn't realize how close Tierney's characters were to the man himself. Tarantino later described him as a "complete lunatic" and said that he personally challenged every aspect of his director's filmmaking. On a day off, Tierney shot a gun at his nephew and was arrested, going straight from a bail hearing to finish work on *Dogs*. He alienated everyone on set, and by some reports got in a fist-fight with Tarantino that ended with the aging star being fired.

SEE ALSO:

Reservoir Dogs

T

TOES: SEE FEET

TRAVOLTA, JOHN

SEE ALSO:

Career resurrection

Pulp Fiction

By the early 1990s John Travolta was generally considered a has-been. The star of *Grease* and *Saturday Night Fever* had faltered in the 1980s with the ill-conceived sequel *Staying Alive* and failed starring roles (*Two of a Kind*) before apparently washing up in the light baby comedy franchise of *Look Who's Talking*. Meanwhile, Tarantino wrote the character Vince Vega for Michael Madsen, but Madsen was committed to *Wyatt Earp* and wasn't available. When Tarantino met Travolta he saw something that fitted, so he turned down Daniel Day-Lewis (!) and relaunched Travolta's career. The narrative around Travolta's comeback helped the film, but the juiciness of the role and his superb performance boosted Travolta's career in turn. Vince allowed him to dance, yes, but it also showcased him as an action man and a character actor. Travolta capitalized on that success through the 1990s and early 2000s, with leading man turns in films like *Face/Off* and *Get Shorty* and outrageous villainy in *Swordfish* and *Broken Arrow*. In 2023, Tarantino expressed the hope that Travolta would reunite with him on his planned tenth and final film, but either way their collaboration remains a stand-out for both.

TRUE ROMANCE (1993)

SEE ALSO:
My Best Friend's Birthday
Natural Born Killers
Pitt, Brad

The late Tony Scott directed 1993's *True Romance*, but it comes from a Tarantino script, and feels steeped in its writer's interests. Our hero, Clarence (Christian Slater), works in a comic-book store – close enough to a video store – and meets his dream girl (Patricia Arquette's Alabama) at a late-night Sonny Chiba movie marathon. She is charmed by his arcane knowledge and falls madly in love with him. They impulsively get married, but decide to set themselves up by driving from Detroit to LA to sell a fortune in cocaine they have stolen from Alabama's pimp. Alas, its gangster owners pursue them with murderous intent. Scott spotted Tarantino's talent early, trying to buy the scripts for both *True Romance* and *Reservoir Dogs* after Tarantino contrived to get them to him. But Tarantino wanted to keep one for himself, so Scott chose this and the rest is history. Scott largely filmed Tarantino's script as written, except to make the story linear: the script originally began with a later first-act scene featuring Samuel L. Jackson's drug dealer discussing cunnilingus (as a wannabe screenwriter he grabbed attention by putting something shocking on the first page). Scott also added a happy ending, with Clarence and Alabama surviving to ride off into the sunset. Tarantino disliked that (his script killed off Clarence) but later

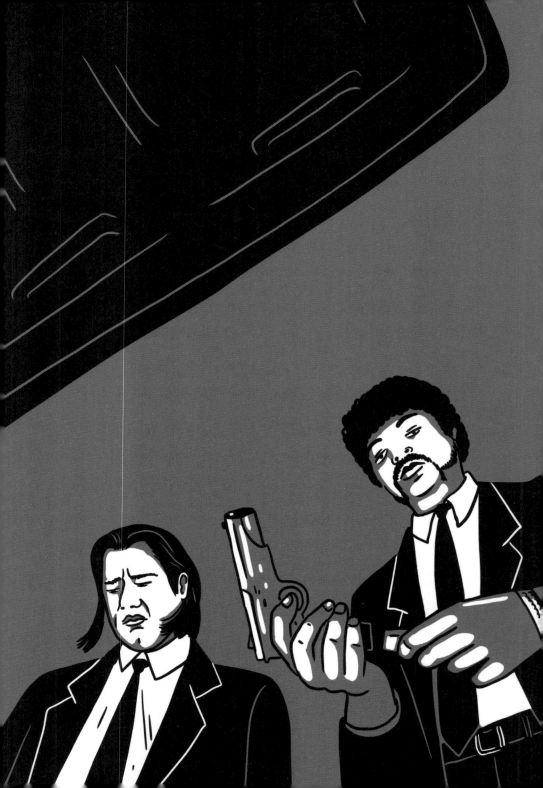

said that it fitted the movie that Scott made. The first act shares DNA with Tarantino's unmade film *My Best Friend's Birthday*, but it's far more developed and much funnier. Scott also attracted a starry cast, with Christopher Walken and Dennis Hopper facing off as a senior gangster and Clarence's dad respectively; Gary Oldman playing a scarred rasta pimp (a role Tarantino wrote for himself); Brad Pitt a laidback stoner and Val Kilmer the Elvis that Clarence sees in his (possibly psychotic) visions. It's vulgar, brash and primary coloured, but there is a youthfully romantic glow to its love story – and it is, looking back, *very* Tarantino. The film flopped at the US box office, taking $12.6 million on a $12.5-million budget, but it gained a new audience after Tarantino became a household name a year later. It has also shown unexpected legs, inspiring pop-culture references and even shaping a TV giant: it was James Gandolfini's performance as one of Walken's henchmen here that got him an audition for *The Sopranos*.

TRUNK SHOT

Tarantino doesn't shoot coverage: he picks his angles and sticks to them. One shot he has returned to repeatedly is the trunk shot. In *Reservoir Dogs*, *Pulp Fiction*, *Jackie Brown*, *From Dusk Till Dawn* and *Kill Bill* it's a literal shot from inside the boot

SEE ALSO:

Jackie Brown

Richardson, Robert

of a car, usually that of a hostage staring into the barrel of a gun. But Tarantino uses a similar trick in *Inglourious Basterds* and *Django Unchained*, too, with a shot from a low angle, looking up at a figure who looms between the camera and the sky. Think of Django looming over Lil Raj Brittle, or Raine and Donowitz in the final shot of *Basterds*, admiring their carving. This shot was not a Tarantino invention: it was used as early as 1948's *He Walked By Night*, and in movies from *Mad Max Beyond Thunderdome* to *Uncle Buck*. But it's become so associated with Tarantino that most trunk shots since *Pulp Fiction* have been a conscious attempt to capture the same cool edge associated with his crime films. That's particularly noticeable in its repeated use in TV shows like *Supernatural* or *Breaking Bad*, and video game franchises like *Grand Theft Auto*.

UNIVERSE, SHARED

Long before the Marvel Cinematic Universe made interlinked films cool, Tarantino was tying his movies together through small details. Brands he invented and character links run between his films and, occasionally, those of his friends. The most famous is Michael Madsen's Vic Vega in *Reservoir Dogs* and John Travolta as his brother Vince Vega in *Pulp Fiction*. But Tim Roth's character in *The Hateful Eight* is "English" Pete Hicox, and is in Tarantino's mind the great-great grandfather of Michael Fassbender's Lt Archie Hicox in *Inglourious Basterds*. That film's Donny Donowitz (Eli Roth) is the father of the film producer Lee Donowitz (Saul Rubinek) in the Tarantino-written *True Romance*. Father and son lawmen Earl McGraw (Michael Parks) and Edgar (James Parks; his real-life son) appear in *Kill Bill*, but Earl made his debut in Robert Rodriguez' *From Dusk Till Dawn* and Edgar would appear in its sequel. Both men also feature in *Death Proof*, while Earl appears in *Planet Terror* and Edgar in Rodriguez's *Machete*. There are echoes of Mia Wallace's cancelled TV show *Fox Force Five* in *Kill Bill*'s Deadly Viper Assassination Squad, suggesting that the real-life killers fictionalized their exploits – or that Bill modelled his team on an old TV show. In *Reservoir Dogs*, Vic's parole officer is Seymour Scagnetti, brother of Tom Sizemore's Jack

SEE ALSO:

Double-V Vega

Red Apple Cigarettes

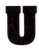

Scagnetti in *Natural Born Killers*. Tarantino himself has said that characters in his "realer-than-real" movies would go see some of his other films. So the characters in Pulp Fiction are "realer-than-real", but might watch *From Dusk Till Dawn* at the cinema; the characters in *Once Upon a Time... In Hollywood* are real, and might (years later) watch *Kill Bill*. This would suggest that all the films featuring the McGraws must be movie-movies and not part of the "realer-than-real" universe, since they appear in at least two (*From Dusk Till Dawn* and *Kill Bill*) that are definitely "movies" – so *Death Proof* and *Planet Terror* must also be movie-movies. Then there are connections that might be coincidence: Sgt Donowitz (Eli Roth) in *Inglourious Basterds* masquerades as an Italian filmmaker called Antonio Margheriti, who was a real Italian director active mainly from the 1960s to the 1980s. In the Tarantino universe, Margheriti directed Rick Dalton in *Operazione Dyn-O-Mite*. So are the two related? It's unclear. This has sent fans down endless rabbit holes of speculation: there are even theories that Rick Dalton's "Bounty Law" might be inspired by the exploits of bounty hunters Django and King Schultz. Only Tarantino could clear it all up, but given his fondness for mysteries that seems improbable.

UNMADE FILMS

As an in-demand director for thirty years now, Tarantino has been linked with many films that never came to pass. Aside from his early attempts to make a Bond movie and the many possible sequels to his own work, endless rumours have swirled around the writer-director; many were comic-book movies or genre remakes. After *Reservoir Dogs*, he reportedly considered a film about Marvel hero Luke Cage, with Laurence Fishburne starring, and was later said to have written a Silver Surfer movie. He was connected to both a *Green Lantern* and an *Iron Man* movie in the late 1990s, and briefly attached to a *Man From U.N.C.L.E.* film (he wanted to cast George Clooney). Warner Bros hired him in 2007 to adapt *Westworld* for Arnold Schwarzenegger but fired him over creative differences (it's admittedly hard to imagine Arnie delivering Tarantino dialogue). He has flirted with the idea of a disaster movie, a screwball comedy, a pure kung fu movie, a 1930s gangster movie, a medieval adventure, a sci-fi or a family film (no swearing? Unthinkable). Several times he's come close to making a spy movie: as well as considering Bond and U.N.C.L.E., he expressed enthusiasm for Len Deighton's Bernard Samson trilogy. In the end, however, he has generally chosen in favour of his own, original stories, with remarkable success.

SEE ALSO:
Bond, James Bond
Crimson Tide
Double-V Vega
Kill Bill: Vol. 3

SEE ALSO:

Avary, Roger

The Films of Rick Dalton

VIDEO ARCHIVES (PODCAST)

This podcast launched in July 2022 and sees Tarantino and his former co-worker Roger Avary watching and discussing films from the Video Archives inventory. Sometimes it's something neither man has seen before; sometimes it's a film one is eager to show the other. Avary's daughter Gala acts as the show's announcer and one of its producers, but the two directors decide what to talk about with no strict rules; most episodes focus on two or more films but one episode was entirely devoted to Bob Fosse's *Star 80* (1983) and another to Sam Peckinpah's *Straw Dogs* (1971). Two episodes were billed as memorials to Rick Dalton, after the (fictitious) actor "passed away" on 19 May 2023. Each has an "After Show" episode alongside, with more chat between the two directors and Gala, and there's now a spin-off interview show, *The Gala Show*, where the younger journalist interviews interesting people about whatever their passions are. It's not the most consistent podcast in the world, but it offers some fascinating insights.

VIDEO ARCHIVES (SHOP)

Video Archives was an unassuming VHS rental store in a mini-mall on Sepulveda Boulevard in Manhattan Beach, Los Angeles. It opened in the

SEE ALSO:

Avary, Roger

Technology

True Romance

early 1980s and was a film fan hangout for over a decade. Owners Lance Lawson and Rick Humbert prided themselves on a wide selection of modern and classic Hollywood, foreign films and indie and cult classics. They hired film obsessives as clerks, including a young Tarantino, who worked there for five years; Roger Avary; and future documentary filmmaker Daniel Snyder. Other former clerks appear in early Tarantino films, notably Stevo Polyi in *Reservoir Dogs* as Sheriff #4 and in both parts of *Kill Bill*. The staff's camaraderie informed the screenplays that Tarantino wrote, particularly characters like *True Romance*'s Clarence. Tarantino's success with *Reservoir Dogs* made the store famous, and it briefly became a port of call for *Dogs*' fans to buy T-shirts and merchandise: Tarantino celebrated the film's VHS launch there in 1993. Unfortunately, Video Archives closed early in 1994. Soon after, Tarantino bought the entire inventory in 1995 and essentially rebuilt the store in his home.

VIOLENCE

The single thing that everyone knows about Tarantino films is that they are violent. The levels of mayhem have ebbed and flowed – they're lower in, say, *Jackie Brown* than *Kill Bill: Vol. 1* – but there's method to his characters' bloody madness. Violence can be an entertainment in Tarantino

SEE ALSO:

Kill Bill: Vol. 3

X-rating

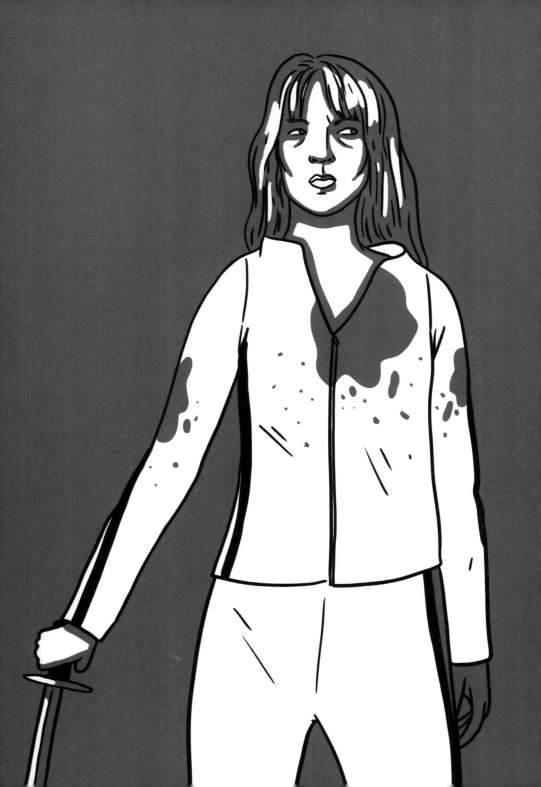

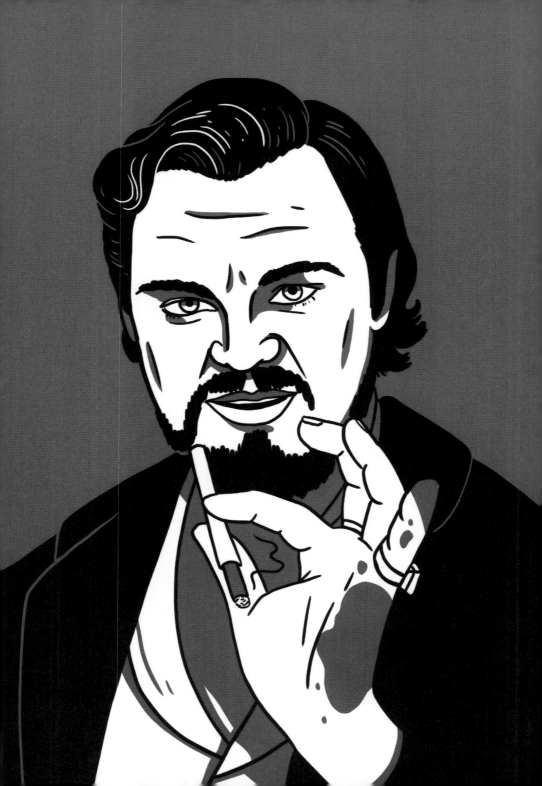

movies but it's also a punctuation, a repudiation of the bad and sometimes the tragic fate of the good. There is a catharsis and a wish fulfilment in seeing Hitler blown apart, or the Manson family stopped violently in their tracks, or slavers turned aside. There's also a huge emotional impact when someone sympathetic, a Mr Orange or a Shoshana, is taken down. Sometimes Tarantino violence is on the cartoonish side – in *Kill Bill* or *Death Proof* – but more often it's something that leaves bloody, painful and lasting consequences. That's even true in *Kill Bill*: look at the Bride talking to Vernita Green's young daughter. Having watched adult films since he was seven years old, Tarantino himself has always been comfortable with violence. He told *Empire* that, "Violent films don't turn children into violent people. They may turn them into violent film-makers, but that's another matter altogether." He's drawn criticism for his bloodiness and there have been campaigns to ban or censor his films, but he has held true to the kind of film he wants to make. He told *The Hollywood Reporter*, after *Django Unchained*, "Not one word of social criticism that's been leveled my way has ever changed one word of any script or any story I tell. I believe in what I'm doing wholeheartedly and passionately. It's my job to ignore that."

WAIT UNTIL DARK (1998)

SEE ALSO:
The Hateful Eight
Ten Movies

In April 1998, Tarantino made his Broadway debut in a revival of this 1966 Frederick Knott play. Marisa Tomei starred as a blind woman menaced by a trio of thugs led by Tarantino's Harry Roat Jr (*Avatar*'s Stephen Lang played another). The play was a big hit in 1966 for Lee Remick and Robert Duvall, succeeded by a film with Audrey Hepburn and Alan Arkin the following year. But thirty-one years later, *Variety* called it "pulp theatre", which seems appropriate to Tarantino, and compared his performance favourably to Arkin. The general critical reaction, however, was vicious. There was wide agreement that the play had dated badly, and that the production lacked tension. Many saw arrogance in Tarantino's decision to jump from bit parts in film and TV to a leading role on Broadway, and he bore the brunt of the abuse. His name helped secure $3 million in advance ticket sales and attendance remained strong, so that the play closed after a respectable ninety-seven performances. But the scars remained. Years later, he told *Empire* that the experience had been "traumatic" and "a huge commitment of time", and he has not returned to the stage since. He has, however, expressed interest in writing or directing theatre after he retires from film directing, so he may again see the lights of Broadway.

WALTZ, CHRISTOPH

Austrian star Christoph Waltz had an international breakthrough as the ruthless SS Colonel Hans Landa in Tarantino's *Inglourious Basterds*. The character had almost stymied Tarantino when casting; he worried that no actor could perform what he had written, speaking his dialogue fluently in four languages, and momentarily considered abandoning the film. Waltz's successful, multi-lingual audition enabled the whole shebang to proceed. Tarantino kept the actor almost a secret from the rest of the cast. He asked Waltz to hold back on his performance at the table read, and requested that he not rehearse with Brad Pitt or Diane Kruger; instead, he ran lines with Waltz personally. That way no one knew what to expect in advance, and Waltz had the same seismic impact as Landa himself. His strategy worked. Waltz swept acting awards at Cannes, the Academy Awards, the BAFTAs and many more. The pair reunited for *Django Unchained*, where Waltz played German bounty hunter King Schultz, a role written for him. That was a far more sympathetic figure, a man who could be ruthless in tracking down his bounties – look at that early scene in Texas – but who also has a strict moral code. Alas, his code proved his undoing. Schultz's inability to hide his disgust with Calvin Candie and shake the slaver owner's hand is

SEE ALSO:
Django Unchained
Inglourious Basterds
Monologuing

the final giveaway of his plan to steal Broomhilda. Instead, Schultz shoots Candie and is instantly gunned down in retaliation. It was a deeply powerful, and deeply human, moment in a film that could have tilted too far towards dark fairytale. Again, Waltz won the BAFTA and Oscar for his work. Since working with Tarantino, Waltz has bolstered his CV with the role of Blofeld in *Spectre* and work with Guillermo del Toro, Wes Anderson and many more – but his work for Tarantino remains his most successful.

WEINSTEIN, HARVEY

SEE ALSO:
Pulp Fiction

The indie film producer, founder of Miramax and later the Weinstein Company, Harvey Weinstein, was thoroughly disgraced as the focus of the #MeToo investigations that rocked Hollywood in 2017. Over eighty women accused Weinstein of harassment, sexual assault or rape and in 2020 he was found guilty on two felony counts. Prior to that time, however, he was hugely influential in film. As a producer, awards campaigner and head of the "mini-major" studio Miramax, Weinstein was responsible for shepherding not obviously commercial films to breakout success and for creating Hollywood careers from scratch. Miramax distributed *Reservoir Dogs* and was key in making *Pulp Fiction* and turning it into a huge financial and

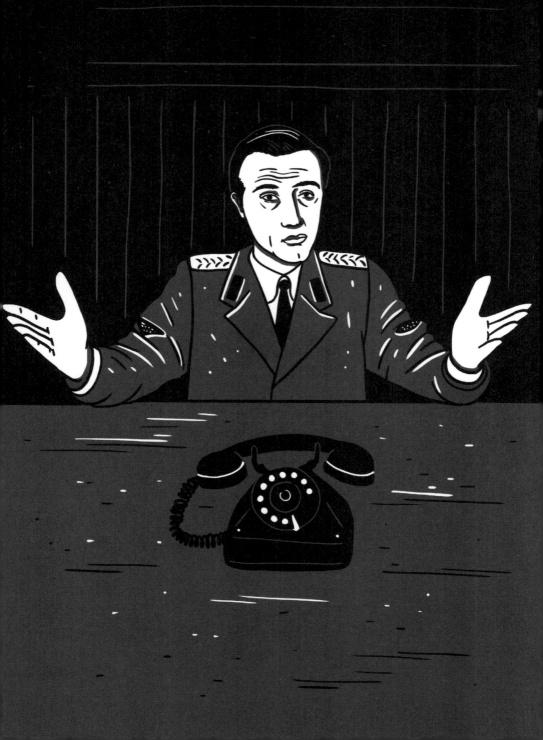

critical success. After that, Harvey and his brother Bob, through Miramax, Bob's Dimension Films and the Weinstein Company (founded in 2005), worked on every Tarantino film for two decades. That only finished after *The Hateful Eight*, in 2015. After the 2017 revelations Tarantino said he regretted not doing more to challenge Weinstein when he heard about bad behaviour, saying that he "marginalized" the incidents in his own mind and failed to consider the possibility that there was a pattern of abuse. Speaking to *The New York Times* he said, "I'm calling on the other guys who knew more to not be scared. Don't just give out statements. Acknowledge that there was something rotten in Denmark. Vow to do better by our sisters. What was previously accepted is now untenable to anyone of a certain consciousness." Tarantino said that he had tried to reach Weinstein to encourage him to "face the music" but his calls had gone unanswered.

WILSON, FLOYD RAY

In his book *Cinema Speculation*, Tarantino credits a figure called Floyd Ray Wilson with inspiring him to become a screenwriter. In Tarantino's account, Wilson was a Black man who rented a room from Tarantino's mother Connie in the late 1970s. A film enthusiast, like the young Tarantino, the two frequently talked movies. But Wilson was also a

SEE ALSO:

Cinema Speculation

Zastoupil, Curtis

wannabe screenwriter, and it was in seeing his stories take shape that the teenager was inspired to consider writing screenplays. Wilson's never-made screenplay about a charismatic Black cowboy in an epic revenge Western was, Tarantino says, an influence on *Django Unchained*. Wilson gets a shout-out in the novelisation of *Once Upon a Time...* when Rick Dalton is described as starring in "an Italian-Spanish co-production called *Red Blood, Red Skin*, based on the Floyd Ray Wilson novel *The Only Good Indian Is a Dead Indian*". He's also referenced in *Pulp Fiction*: the boxer that Bruce Willis' Butch accidentally kills in the ring is called Floyd Wilson – though that character was originally named Floyd Willis in the script, and his name was changed once Bruce Willis joined the cast, to avoid distraction, so perhaps that was a partial coincidence. In any case, film fans have much to thank Wilson for in inspiring the young Tarantino.

WRIGHT, EDGAR

Tarantino was a huge fan of Edgar Wright's rom-zom-com (romantic zombie comedy) *Shaun of the Dead*, which he described as the best British film he'd seen in nearly twenty years. He also named *Hot Fuzz* his favourite movie of 2007. Wright in turn, like most of his generation, was a huge Tarantino fan, creating a shot-for-shot *Pulp Fiction* homage in

SEE ALSO:

Anders, Allison

Grindhouse

Soundtracks

one episode of his TV show *Spaced* and referencing *Reservoir Dogs* in another. He even invited Tarantino along to record a DVD commentary on *Spaced*'s first episode, which swiftly degenerated into unrelated chitchat about films they enjoyed (or not in the case of the *Star Wars* prequels). Wright shot a fake trailer for a film called *Don't!* with an array of British stars in the Hammer horror style for *Grindhouse*. By then they had become friends. Notably, Tarantino inspired the name for Wright's *Last Night in Soho*: Wright was talking to him about the song "Hold Tight" by Dave Dee, Dozy, Beaky, Mick & Tich that Tarantino uses in *Death Proof*, and Tarantino played another song by the same group: *Last Night in Soho*. Tarantino quoted something Allison Anders had said to him, calling it "the best title music for a film that's never been made". Wright put it on a playlist he listened to while writing his script and eventually made it his film's title. The pair remain close, sharing an informal British film club during the Covid-19 lockdown to watch films that had previously escaped their voracious viewing appetites.

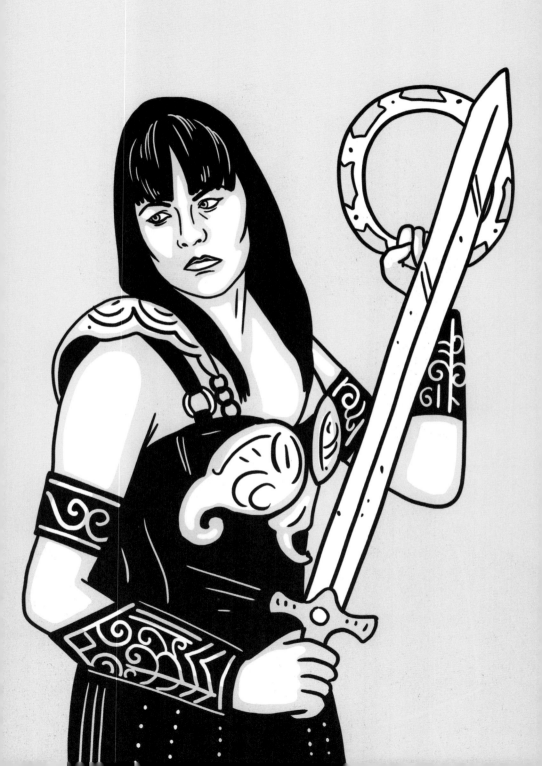

XENA: WARRIOR PRINCESS

Among the many TV shows that Tarantino has expressed enthusiasm for over the years is *Xena: Warrior Princess*, the more successful spin-off to *The Adventures of Hercules*. "*Xena* is the show I always wished *Wonder Woman* was, *Charlie's Angels* was. *Xena* has no apologies; *Xena* is a really cool show," said Tarantino. He admired Lucy Lawless's performance as Xena, the warrior with a dark past who tried to do good to atone, to some degree, for her misdeeds, and enjoyed the largely practical action scenes. Tarantino's regular collaborator, Zoë Bell, built her professional reputation as a stuntwoman on *Xena*, which is how she came to work on *Kill Bill* and then on every Tarantino movie since.

SEE ALSO:
Alias
Bell, Zoë
CSI

X-RATING

OK, so Tarantino started his career too late to face the possibility of an X-rating, which was retired several years before *Reservoir Dogs*. But he's had near-misses with censorship boards around the world. In the US, *Grindhouse* nearly received a commercially devastating NC-17 rating – reportedly due to the contents of Eli Roth's *Thanksgiving* trailer rather than to Tarantino's own efforts. Irish censors refused to certify either *Natural Born Killers* or *From Dusk Till Dawn*, with the latter waiting eight

SEE ALSO:
Natural Born Killers
Violence

X

years for an Irish release. In the UK, the murder of James Bulger in 1993 created a moral panic shortly after the release of *Reservoir Dogs* that led to a delay of over a year for its VHS debut. In recent years, however, the only major censorship battle that Tarantino has faced was with Chinese authorities over *Once Upon a Time... In Hollywood*. While the censors did not explain their refusal to certify the film, the understanding was that they wanted him to cut the Bruce Lee scenes. He refused, and the film was not released in China.

YE

Ye, the artist formerly known as Kanye West, claimed in an interview with Piers Morgan in October 2021 that Tarantino "got the idea" for *Django Unchained* from him. The rapper claimed that he pitched it to Jamie Foxx and Tarantino as a video concept for his 2005 song "Gold Digger", which featured Foxx on vocals. The video that emerged was a relatively simple cut of clips of Ye, Foxx and a parade of pin-up style women posed on magazine covers, directed by music video specialist Hype Williams. But Tarantino acknowledged that Kanye had an idea for a video where he would play a slave, and that it was a funny idea. "It was meant to be ironic, like a huge musical, no expense spared, with him in a slave rag outfit," Tarantino recounted on *Jimmy Kimmel Live!* Ye has never elaborated further on how the idea he suggested came close to the story of *Django Unchained*.

SEE ALSO:
Django Unchained
"Telephone"

YUKI'S REVENGE

Tarantino originally conceived an extra chapter in *Kill Bill: Vol. 1*, which would have involved a huge battle between Uma Thurman's The Bride and Yuki Yubari. She's the "even crazier" twin sister of Chiaki Kuriyama's Gogo Yubari, aka the schoolgirl assassin with the meteor hammer who guards O-Ren Ishii.

SEE ALSO:
Kill Bill: Vol. 3

Y

After The Bride kills her sister, the idea was that Yuki would track her to LA and, following her dispatch of Vernita Green, engage in an epic gun battle through the streets. Tarantino wasn't sure if he wanted it in live action or as an anime insert, the same way that he told the backstory of O-Ren, but either way he knew the sequence could cost another $1 million and add more time to an already lengthy, eventually two-part movie. So he reluctantly decided to drop it. He does, however, consider the character of Yuki to be canon, and has talked about including her in *Kill Bill: Vol. 3*, should it happen.

ZASTOUPIL

Tarantino's mother married a musician named Curtis Zastoupil when he was a child. His name was legally changed to Zastoupil, a surname he used for most of his teenage years until he took that of his birth father, Tony Tarantino, because, he said, he thought it sounded cool. More recently on Marc Maron's *WTF Podcast*, Tarantino has expressed some second thoughts about that and said that, if he were starting now, he'd probably use his middle name, Jerome, as a surname. Curt Zastoupil, however, gets two tributes in *Once Upon a Time... In Hollywood*. In the film, when Cliff visits the Spahn Ranch, Tex is earning some money by guiding two visitors, Connie from Tennessee and Curt, on horses around the ranch's open land. That's a reference to Tarantino's mother and stepfather, and echoes a memory he has of riding at what he thinks was Spahn Ranch as a boy. In the novelization, when Rick Dalton and Jim Stacy go to a bar called The Drinker's Hall of Fame after shooting on TV show *Lancer*, Curt Zastoupil is the resident piano player. Zastoupil has a chat with the two, asking Dalton for an autograph for his six-year-old son Quint, aka Quentin. He says the kid is a big fan of Dalton's TV show *Bounty Law* and his film *The Fourteen Fists of McCluskey*. It's a warm tribute to a man who was clearly important in the young

SEE ALSO:

The Films of Rick Dalton

Once Upon a Time... In Hollywood

Z

Tarantino's life, and one that specifically hails both his fatherly instincts and his piano-playing skills.

ZED'S DEAD, BABY, ZED'S DEAD

SEE ALSO:
Eddie Presley
Pulp Fiction

Tarantino scripts positively burst with quotable lines, but for some reason "Zed's dead, baby" has stuck with many people. Zed is the rapist security guard played by Peter Greene in *Pulp Fiction*, who – along with his equally grotesque brother Maynard (Duane Whitaker) – takes Bruce Willis' Butch and Ving Rhames' Marsellus Wallace captive. Zed rapes Marsellus before Butch frees himself and slices Maynard open with a katana. Marsellus then shoots Zed in the genitals before calling for back-up to torture him to death. While Butch doesn't see him expire, he knows Zed is to all intents and purposes the most dead man on Earth – hence this line to his girlfriend. It's a great illustration of Marsellus' ruthlessness, Butch's grasp of reality and karmic justice all at once.

ZOMBIE, ROB

SEE ALSO:
Grindhouse

The musician Rob Zombie began his career in 1985 as the frontman of White Zombie before going solo in 1996. He turned filmmaker in 2000 with *House Of 1000 Corpses*, which became notorious before

release when original studio Universal refused to distribute it, citing its gore and violence. Zombie reacquired the rights and shopped it around to studios himself. Lionsgate finally brought out an edited version in 2003. It did well enough to fuel a sequel, *The Devil's Rejects*, and even drew comparisons to Tarantino's work. By 2007, when Zombie was asked to contribute a trailer to Tarantino and Rodriguez's *Grindhouse*, he was an established horror director lining up a remake of John Carpenter's *Halloween*. He created, as his fake film, "Werewolf Women of the SS", a Nazi-monster exploitation film that is influenced by *Ilsa, She-Wolf of the SS* but very much its own beast. Zombie shot almost half an hour of footage and really struggled to chop it down to trailer length, but still found time to feature Udo Kier as a Nazi boss and, for no obvious reason (in the finest grindhouse tradition) Nicolas Cage as Fu Manchu.

ABOUT THE AUTHOR

Helen O'Hara is an author and film journalist living in London. After growing up in Northern Ireland and qualifying as a barrister, she decided that a proper job would be far too boring and ran away to write about movies. She worked initially for *Empire* magazine, where she remains Editor-at-Large, and has been published by The *Guardian, Time Out, Grazia* and many more. Helen is also a regular broadcaster on film for the *BBC*, the *Empire Podcast* and others. Her previous books include *Women vs Hollywood: The Fall And Rise Of Women In Film* (Robinson), which was a *BBC Radio 4* Book of the Week and *Sunday Times* Film Book of the Year.

ACKNOWLEDGEMENTS

Thanks to my editor Joe Cottington, assistant editor Emma Hanson, designer James Empringham, copy editor Helena Caldon and proofreader Jane Donovan for all their hard work on the book. It's less a case of thanks and more one of massive kudos to illustrator Laurène Boglio for her artwork, since she's very much a co-creator. Finally, thanks and love to my ever-supportive Andrea Campanella, who watched and rewatched lots of wild and crazy movies with me while I was writing this book. In retrospect, he was right, and watching *Planet Terror* immediately after dinner was a terrible idea.

Published in 2025 by Welbeck
An Imprint of HEADLINE PUBLISHING GROUP LIMITED

1

Text © Helen O'Hara 2025
Illustrations © Laurène Boglio 2025
Design and layout © Headline Publishing Group Limited 2025

This book has not been authorized, licensed or endorsed by Quentin Tarantino, nor by anyone involved in the creation, production or distribution of his work.

Apart from any use permitted under UK copyright law, this publication may only be reproduced, stored, or transmitted, in any form, or by any means, with prior permission in writing of the publishers or, in the case of reprographic production, in accordance with the terms of licences issued by the Copyright Licensing Agency.

Cataloguing in Publication Data is available from the British Library

ISBN 9781035417575

Printed in China

Headline's policy is to use papers that are natural, renewable and recyclable products and made from wood grown in well-managed forests and other controlled sources. The logging and manufacturing processes are expected to conform to the environmental regulations of the country of origin.

HEADLINE PUBLISHING GROUP LIMITED
An Hachette UK Company, Carmelite House
50 Victoria Embankment, London EC4Y 0DZ

The authorised representative in the EEA is Hachette Ireland,
8 Castlecourt Centre, Dublin 15, D15 XTP3, Ireland (email: info@hbgi.ie)

www.headline.co.uk
www.hachette.co.uk

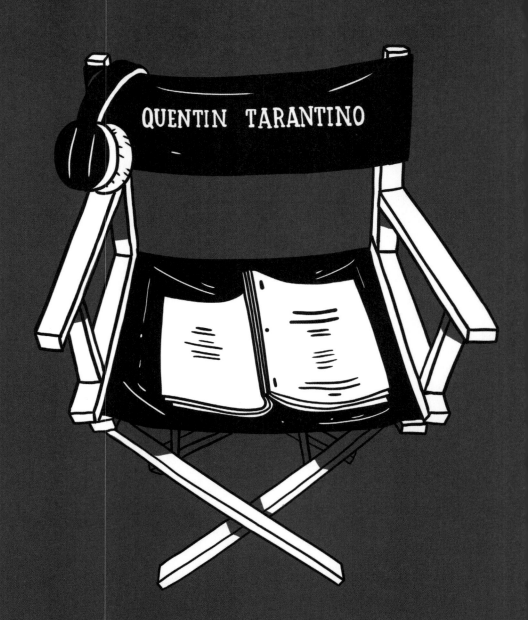